IMAGES
of America

MANATEE COUNTY

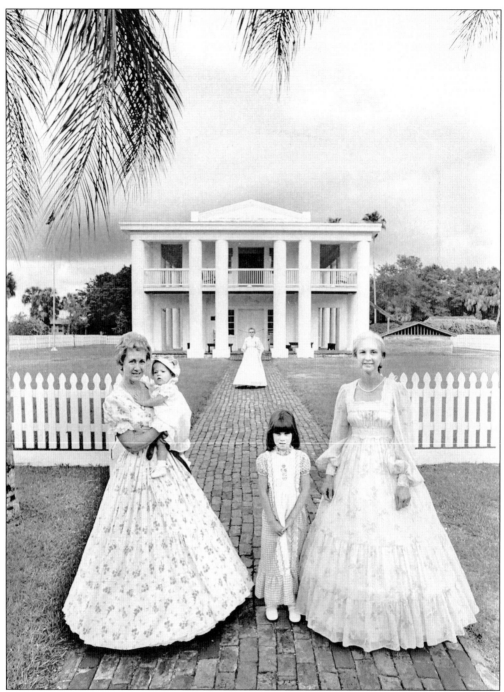

The mansion at Ellenton was built by Maj. Robert Gamble in 1842 and was part of his 3,500-acre sugar plantation. Confederate secretary of state Judah P. Benjamin hid there during his escape to England in 1865. In 1925, the decaying mansion and 16 acres were purchased by the United Daughters of the Confederacy and donated to the state. The unidentified persons in the photograph are wearing mid-19th century costumes on the grounds of the historic site, which is open to the public. (Courtesy of the Manatee County Public Library Historic Photograph Collection.)

IMAGES
of America

MANATEE COUNTY

Jim Wiggins

ARCADIA
PUBLISHING

Published by Arcadia Publishing
Charleston SC, Chicago IL, Portsmouth NH, San Francisco CA

Printed in the United States of America

Library of Congress Catalog Card Number: 2007931702

For all general information contact Arcadia Publishing at:
Telephone 843-853-2070
Fax 843-853-0044
E-mail sales@arcadiapublishing.com
For customer service and orders:
Toll-Free 1-888-313-2665

Visit us on the Internet at www.arcadiapublishing.com

These pages are dedicated to A. K. "Klein" Whitaker (July 12, 1900–September 15, 1988), a graduate of MIT and past president of the Manatee County Historical Society, who set up an archival system with more than 8,000 pictures depicting the county's rich history. He copied and made negatives of photographs and catalogued them in the Eaton Room of the Manatee County Central Public Library in Bradenton. He was born in Bradenton, the son of Dr. and Mrs. Furman Whitaker.

CONTENTS

ACKNOWLEDGMENTS

This book would not be possible without the Manatee County Public Library Historic Photograph Collection and, in particular, the expertise of Michael Gorzka, reference librarian. Unless otherwise indicated, all images used in this publication are taken from this archive collection. Thanks goes to John VanBerkel, library director, for his permission to use the images and to Pam Gibson, reference librarian.

Kate Crawford, my editor at Arcadia Publishing, patiently walked me through the entire procedure with a warm and gracious manner that offered reassurance in moments of frustration. I cannot express my appreciation enough for her guidance and for her patience in working with such a novice.

I am appreciative to those in Manatee County who contribute to the preservation of history, including the Palmetto Historical Commission, Carolyne Norwood and Sissy Quinn of the Anna Maria Island Historical Society, Alice Myers of Palmetto, Minnie Hager of Bradenton, Donna Simpson, and countless volunteers such as the Reverend Herb Loomis, current president of the Manatee County Historical Association. I am indebted to Don Bergeron, park ranger at the Gamble State Park in Ellenton; Nick Norwood, photographer; and for the words of encouragement from family and friends such as Virginia and Blake Whisenant, Sally and Duane Bustle, Sonny Edwards, and in particular, my wife, Colleen. I am also indebted to my daughter-in-law, Stephanie Wiggins, who often rescued me from my ineptness in dealing with my bipolar computer.

I especially appreciate all those writers who left important legacies by recording bits of history for posterity. The list is long. In particular, I am indebted to Joe and Libby Warner for their book *The Singing River*, a history of the people, places, and events along the Manatee River that served as an important resource for confirmation of information included in these pages.

INTRODUCTION

Two great Native American nations, the Timucuan and the Calusa, once inhabited the area that was to be known as Manatee County. It was on these same shores that Hernando de Soto purportedly landed with nine ships and disembarked at Shaw's Point in 1539 with soldiers, livestock, and supplies, moving north along the western regions of Florida until reaching the Mississippi. During the 1700s, the banks of the Manatee River were lined with shacks built by Spanish fishermen drying their catch before it would to be transported and sold in Cuba. It was a land teeming with fish, wildlife, flowing streams, and rich, fertile soil that was waiting to be cultivated.

It wasn't long before settlements appeared up and down the shores of the Manatee River. The first arrival was Capt. William Bunce, a resident of Hillsborough County, who set up a fishing rancho at the mouth of the Manatee River in the early 1800s. The rancho employed approximately 150 Native Americans and runaway slaves. The U.S. government frowned on the operation and destroyed it in 1840 as part of the purging of Native Americans in Florida. The shores of the Manatee River were then opened for development by white men who took advantage of the Armed Occupational Act of 1842, allowing settlers to claim 160 acres of land if they met the conditions of bearing arms and living on the land for five years. The yellow fever epidemic in 1841 hit the area hard, so settlers took great caution in making their decision to establish permanent residency.

Capt. Frederick Tresca and Capt. Archibald McNeil had been trading in the area for several years and raved about the beautiful area and its rich land. They became acquainted with Josiah Gates and his brother-in-law, Miles Price, at Fort Brooke (Tampa) and convinced them to explore the area in 1841. Gates and his family moved there the following year. Several families and friends followed and in 1842 settled nearby on the southern shore to establish a community, which later became known as the Village of Manatee. Maj. Robert Gamble was acquainted with several of the families, including the Braden and Clark families, which, like Gamble, originally came from old aristocratic families in Virginia. They also included the Pinckney Craig, John William Craig, Wyatt, Ware, Ledwith, Reed, and Snell families, who lost everything in North Florida when they suffered financial loss from the collapse of the Union Bank.

Major Gamble acquired 3,450 acres of land on the north side and brought approximately 100 slaves and a ship from New Orleans loaded with the most modern agricultural tools to establish a refinery that produced about 15,000 barrels of sugar annually. The Craigs acquired 1,560 adjourning acres for smaller productions. Wharves were built up and down the Manatee River, and steamboats traversed the waters to New Orleans and points farther north, returning with supplies needed desperately by the pioneer families trying to carve their niche in this new land. From these families, Manatee County was being born.

Braden Castle became a refuge for families during a surge in Native American attacks during the Third Seminole War, followed by the Civil War, which brought plantation life to an end. The Gamble Mansion became the hideout for Judah P. Benjamin, secretary of state for the Confederacy, during his daring escape to England. The Gamble and Craig properties were eventually purchased by the Patton and Leffingwell families, who divided the land into sections that were readily

purchased by anxious buyers. Truck farming became the major source of income, and a spur railroad was built to Ellenton and Parrish from its western neighbor, Palmetto. Meanwhile the south side of the river was developing as the city of Braidentown (Bradenton) grew and became the central business and cultural center. Communities sprouted everywhere. Trees were cleared, houses built, crops planted, and every inch of land was soon saturated with growth.

More than 200 photographs from the 1800s and early 1900s are offered in this book to provide glimpses of Manatee County's rich heritage. Unfortunately not every aspect of early life in the county is depicted simply because of the enormity of the task and because of the lack of credible information or availability of vintage photographs. However, the diversity of life presented in these pages is astounding, and hopefully readers will enjoy getting acquainted with those brave souls who are represented in these pages. Carving out a niche in this pristine wilderness was certainly not for sissies.

One

IN THE BEGINNING

Several factors played important roles in the settlement of Manatee County. First was the end of the Second Seminole War in 1842, which allowed settlers a reprieve from the threat of Native American raids. Second, Congress passed the Armed Occupational Act of 1842, which enabled settlers to claim 160 acres of land if they were able to bear arms and live on the land for a minimum of five years. Third, the collapse of the Union Bank in Tallahassee forced many wealthy plantation owners to move south in search of a new beginning.

Josiah Gates and his family were the first to make their move to the south side of the river to a place where springs flowed freely. The area later became known as the Village of Manatee. Others followed the Gates family, including Joe Baden, the Pinckney Craigs, John William Craig, the Wyatts, the Wares, the Ledwiths, the Reeds, the Clarks, the Snells, and Maj. Robert Gamble, who came primarily from prominent and wealthy aristocratic Virginian families that had moved to the Tallahassee area. Each contributed to the growth and development of Manatee County, which rapidly expanded to communities up and down the Manatee River. Diseases and the Third Seminole War, led by Billy Bowlegs, made life extremely difficult. But it wouldn't be long before crops were planted, artesian wells were flowing, and cattle were grazing on open land.

Unfortunately photographs are not available for many of the earliest pioneers who played important roles in the evolution of one of Florida's most appealing cosmopolitan areas; however, this does not lessen the importance of their presence in Manatee County.

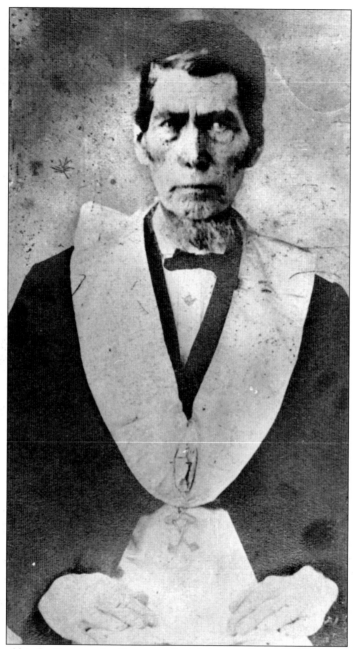

Josiah Gates and his family were the first to settle in Manatee County. They moved to the south side of the Manatee River in 1842 to an area that became known as the Village of Manatee. Capt. Frederick Tresca brought Gates and his family possessions aboard his sloop, the *Margaret Ann*. Gates built a temporary log house and a stockade, and his brother-in-law, Miles Price, cleared the land and planted corn, sugarcane, and tobacco. Gates later built a 24-room house to accommodate his large family and guests. Henry Smith Clark and his family knew the Gateses at Fort Brook (Tampa) and joined them on the Manatee River a few months later. Clark also built a log cabin for temporary housing but also added a small store. Their wives, Mary Gates and Ellen Clark, became good friends.

Maj. Robert Gamble was enticed by Josiah Gates to visit the Manatee area in 1842. After exploring the north side of the river, Gamble purchased 3,450 acres of land and planted 1,500 acres of sugarcane. Heavy machinery was hauled in from New Orleans, and housing was provided for more than 100 slaves. The mansion was built of tabby.

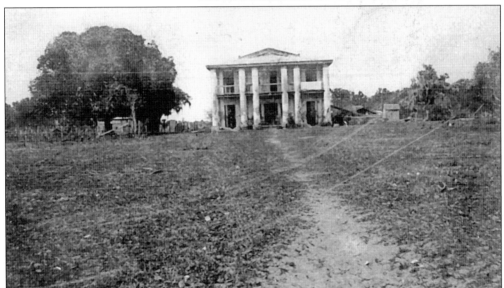

The Civil War ended plantation life, and the Gamble Mansion was vacated and sold. It was occupied after the war by Capt. Archibald McNeil and his family, who were responsible for hiding Judah P. Benjamin, secretary of state for the Confederacy, at the mansion during his escape to England. The estate was purchased by Maj. George Patten in 1873 and occupied for 20 years.

Judah P. Benjamin was the secretary of state for the Confederacy and was a closes advisor to Confederate president Jefferson Davis. Benjamin fled Richmond, Virginia, in April 1865. Alone and dressed shabbily, he posed as a Frenchman and headed south with a bounty on his head. He moved across Georgia and finally reached the Gamble estate on the Manatee River, where he was welcomed by Capt. Archibald McNeil. McNeil was also a wanted man because of his activities as a blockade-runner during the Civil War, taking food and supplies to Confederate troops. Benjamin stayed in the front upstairs bedroom, where he could watch for approaching Union ships on the river. He was then smuggled to Sarasota and eventually made his way to Havana, Cuba, and on to England, where he was admitted as a barrister to the bar of London.

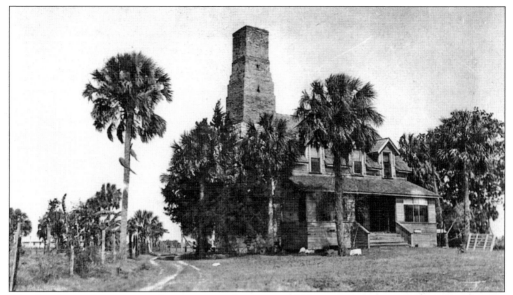

The Pinckney Craig sugar plantation was begun in 1842 on the western edge of the Gamble plantation and was composed of 1,560 acres. It included a 45-foot chimney, which had two furnaces at the base. The sugar mill produced 140,000 pounds of sugar and 8,000 gallons of molasses during its peak season in 1849 and 1850. This photograph was taken in 1942. (Courtesy of the Florida Archives.)

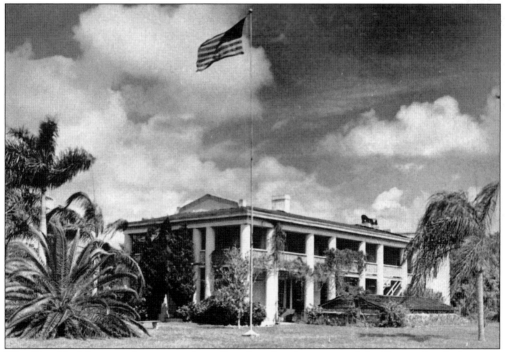

The Gamble Mansion deteriorated rapidly after the departure of the Patten family but was ultimately acquired and renovated by the Judah P. Benjamin chapter of the United Daughters of the Confederacy. The property was deeded to the State of Florida in 1925 and hosted a reunion of Confederate veterans in 1927. Today it is open to the public for daily tours and special events.

After Maj. George Patten's death in 1891, Dudley Patten and his young wife, Ada, moved into the Gamble home with his widowed mother, who died on June 15, 1893. Ada didn't like the big and drafty mansion, so Dudley built her a comfortable wooden home nearby, which still stands today and is open to the public. The home is also the headquarters for the Daughters of the Confederacy.

Julia Atzeroth was born in Bavaria on December 27, 1807, and moved with her husband, Joseph, to Terra Ceia in 1843. They cleared their land with an ax, and Julia assumed the name "Madam Joe." She split her time between Terra Ceia and Tampa, where she ran a beer and cake shop. Joseph died in 1871, and Madam Joe moved in with her daughter, Eliza Fogarty.

The Reverend Leroy G. Lesley was the first Methodist minister in the settlement of Manatee. His son, Maj. John T. Lesley, commanded the small Confederate garrison at Shaw's Point during the Civil War and later helped Judah P. Benjamin in his escape from Tampa to the Gamble Mansion.

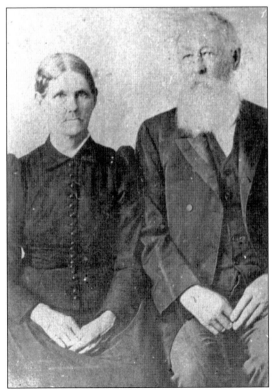

Martha Ann Andress Bishop and Asa Bishop were pioneers in Palma Sola. Martha came with her father, John Andress, at the end of the Third Seminole War in 1859 to Shaw's Point, also known as Bishop's Point. Asa joined the Confederate army and fought in most of the major battles. He returned and built a home on the river but died soon after on November 15, 1893.

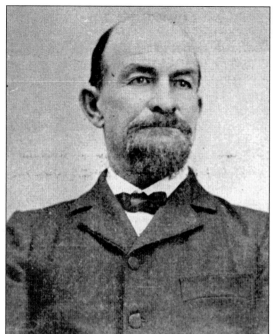

Capt. John Leonidas Hough was born in Mississippi in 1839 and served in the 1st Light Company E-37 during the Civil War. The family came to Manatee County around 1865 and lived near the Manatee Mineral Springs. He served as the first marshal in Manatee and was the Manatee County treasurer from 1888 to 1900. He also supervised the Manatee Avenue extension to Fogartyville.

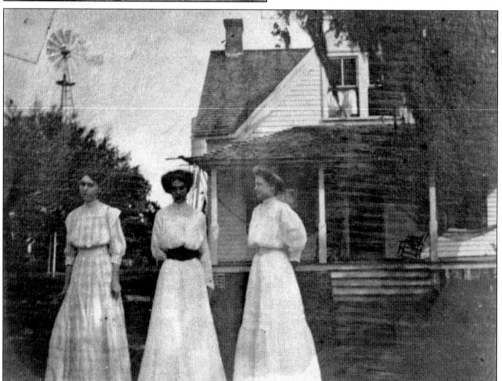

Capt. John Curry first sailed from Key West to the Manatee area in 1859 to buy cattle for the Cuban market. He liked what he saw and purchased Dr. Franklin Branch's property, which consisted of 320 acres and two houses. Pictured in this c. 1905 photograph are several of Curry's descendants, from left to right: Hattie Lenora Curry, Mary Leila Curry, and Nellie Mae Curry.

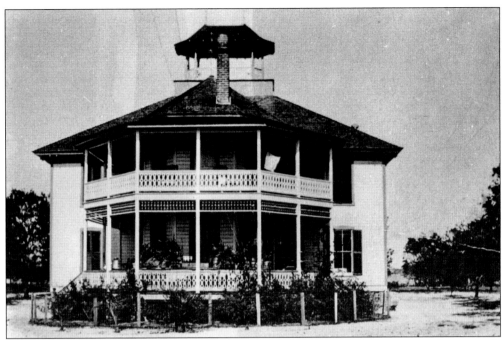

H. W. Curry built this home in 1904 on the east bank of Ware's Creek at its confluence with the Manatee River. The section was known as Curry's Point and became Braidentown's first elite subdivision when it was divided into lots by H. W. Curry's son, Whitney Curry, in 1925. It was renamed Point Pleasant. The first bridge over the deep water of Ware's Creek was built in 1886.

The Tyler homestead in Ellenton was built in the late 1800s north of the railroad and west of Gillette Road. Pictured from left to right are Samuel W. Tyler, Daisy Tyler Wiggins, Jesse D. Wiggins, Myrtle Wiggins, and Julia Wiggins Jones. The individual on the porch is unidentified. Samuel's children were Daisy, Mae, Pearl, and Sam. (Courtesy of Minnie Jones Hager.)

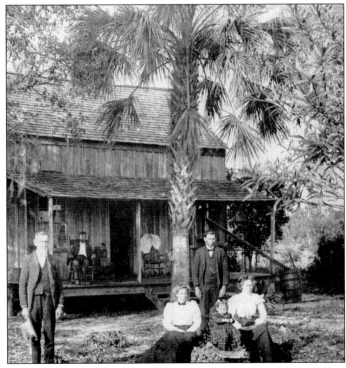

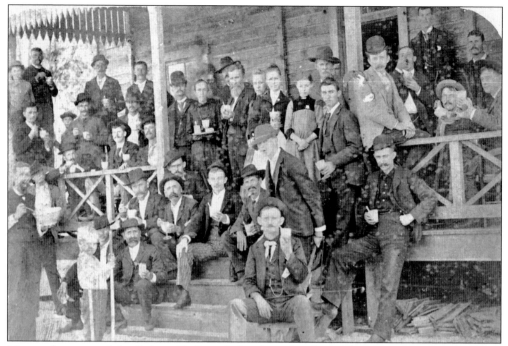

Men and women of the Robert H. Roesch family gather for a Christmas party on the porch of the Roesch home in Braidentown. Everyone appears to be holding a cup of ice cream, but a few are holding drinks. One child is in the photograph, which was taken in 1890, and all are unidentified.

Posing on the porch of Frank B. Gillett's home in Gillette are, from left to right, Lena Cecil Gillett, Frank Gillett, and Lucy Gillett. Unfortunately no photograph could be found of Daniel Gillett, who founded the community of Gillette, which is north of Ellenton. The community added an "e" to the name c. 1900.

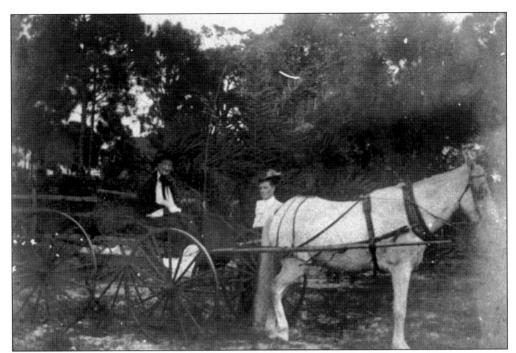

In this photograph taken February 27, 1913, Helen Warner, the wife of Warburton Warner, sits in the buggy holding the reins to the horse, Terry. Her family was partly responsible for the founding of Palma Sola. Standing is Nellie, wife of John E. Balis, who moved to Manatee County in the early 1900s with their four sons, George, Raymond, John, and Ermine.

Anna Keen married A. Y. "Alzie" Carlton on January 2, 1916. Alzie's father, Peter, moved to Myakka by ox-wagon from Bowling Green, Florida, in 1898. Anna was born at Pine Level, which was the old county seat, and she felt like they were moving to "the wilderness" when they moved to Myakka in 1920. The Carlton family became one of Florida's leaders in the cattle industry.

19

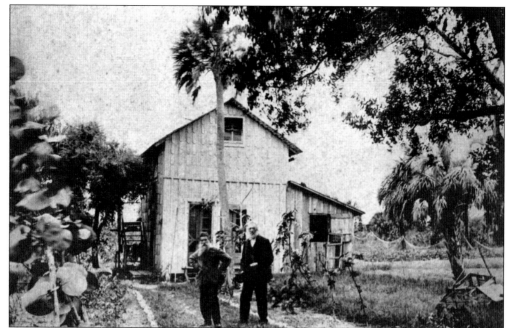

Andrew Gowanlock (right) and his friend James Goddard of Barbados stand in front of Gowanlock's home on Anna Maria Island. Andrew married the widow Elizabeth P. Nichols from Shaw's Point in 1883. They moved to a home near the Bradenton marina, but Andrew rowed his boat daily to his old homestead. The marriage failed. He died in 1911 at his old house at age 103.

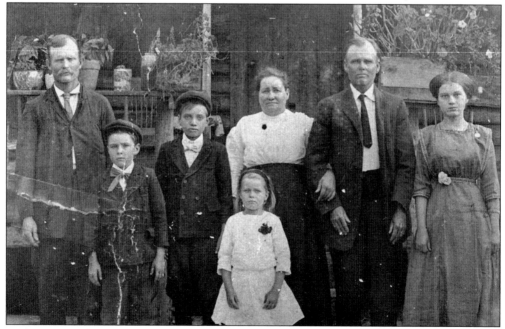

In this *c.* 1910 photograph, the David Rogers family poses in front of their home in the Albritton settlement in northeastern Manatee County. The little girl in the white dress in front is Effie Rogers. Others pictured, from left to right, are Joe, Earl, Singleton, Mattie Davis Rogers (David's wife), David, and Ella.

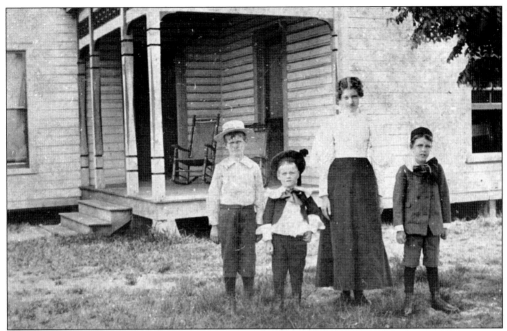

Minnie Stanton stands with, from left to right, her three sons, William, Curtis, and Samuel. Her husband, Samuel Stanton, owned a shipyard in Mateawan, New York, but moved to Braidentown with his family in 1884 after designing and building the *Manatee*, which he docked at his wharf. It was 125 feet long, 32 feet wide, and powered side-wheels at 32 revolutions per minute.

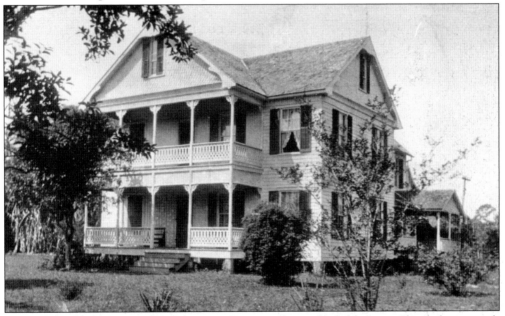

Capt. Bartholomew Fogarty's residence in Fogartyville was built like most Florida homes with large covered porches. This photograph shows goods being unloaded from the wagon with the use of a pulley on the upstairs porch. Brothers John and Bartholomew (called Tole) filed claim to 135 acres in 1887, and their brother, Bill, joined them later. They owned a mercantile store and boat works.

Bartholomew (called Tole) Fogarty sits on the seat of a horse-drawn cart while an unidentified man rides in the back. Fogarty and his wife, Mary, adopted Robert Gerrero, whose parents and two brothers died from yellow fever. One son, also named Bartholomew (called Bat), built his first boat at the age of 19, which he christened *Eclipse*.

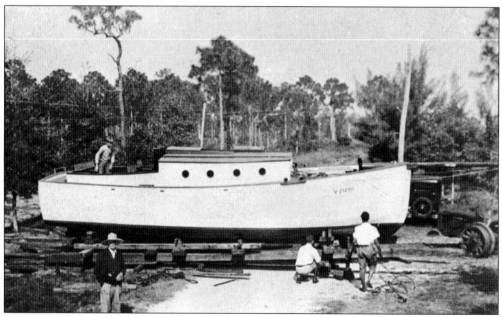

Two men are working on a boat with the registration number V 21290. A boy explores the stern of the boat as an unidentified man stands nearby. The Fogarty Boat Works built more boats than any other in Manatee County. This photography was taken in 1925, approximately 50 years after the first boat was christened.

A. F. Wyman and Philena Trueblood pose on their wedding day on May 10, 1888. Trueblood was the owner of the Braidentown Hotel. The hotel had a private arrangement catering to the growing number of visitors who arrived on the steamer *Margaret*, which made daily trips to and from Tampa. The round-trip fare was $1.50 and included dinner.

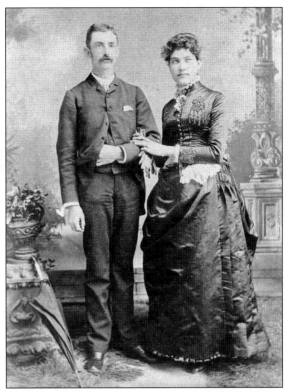

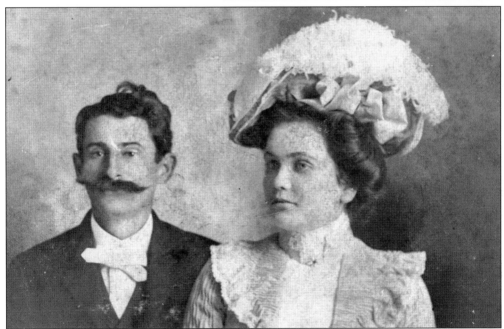

James P. and Mamie Hine pose in their finest dress. James's parents, Miller Jacob Hine and Elizabeth Ann, moved to Mitchelville in 1882 and bought 160 acres. Elizabeth Ann became a teacher at the Rye School. Their son, Leslie, became school superintendent in 1908. His sister Mary married Augustine Willis, a Cortez fisherman, and Ruth, another sister, married Ben Gammage.

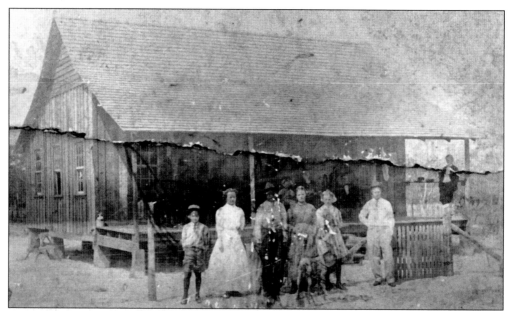

In this c. 1913 photograph, Jacob C. Parrish poses in front of his home with his family in Parrish, which was close to the Hillsborough County line. Pictured from left to right are Jake Jr., Lou Fortner Parrish (Jacob's second wife), Jacob Sr., Mary, Kate, and Jamie.

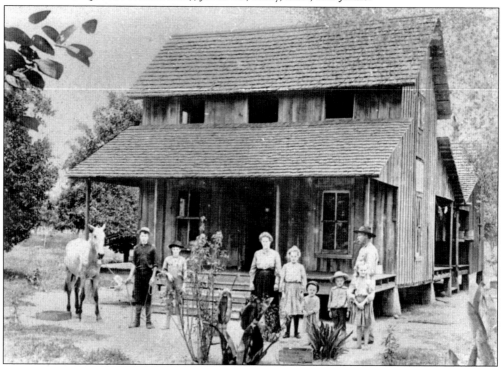

Edward D. Wilson stands with his family at his home in Myakka where he grew oranges and potatoes. He served as the administrator of the estate of Nancy J. High, possibly his mother-in-law. He was a trustee of the Maple Branch School and was described as one of the biggest men in Myakka. He had a brother, Peter, who helped build the schoolhouse in 1911.

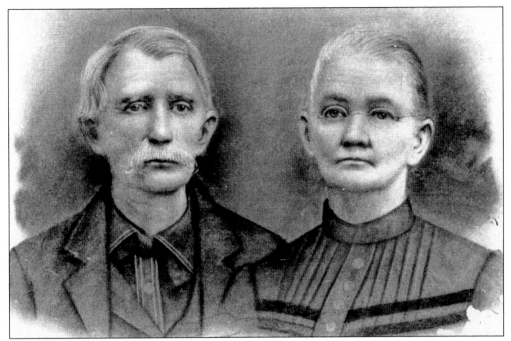

A. J. Pope eloped with Melinda Cason in 1861, and they settled on 160 acres in the Duette area of Manatee County. He served in the Third Seminole War and in the Civil War, where his hand was shattered. They later moved to land east of Rye Road. In spite of his damaged hand, Pope raised livestock, farmed, and worked as a carpenter. The couple had 13 children.

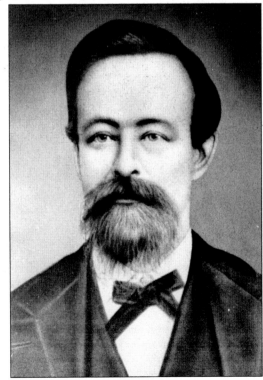

Dr. John Crews Pelot was the assistant surgeon of the Confederacy and was a prisoner during the Civil War. His arrival in Manatee County in 1866 was welcomed. In 1887, he was elected state representative of Manatee County and was reelected in 1897 and 1898. He and his son, John James Pelot, opened a drugstore, which remained in operation through 2004.

Emma Gates, the youngest daughter of Josiah Gates, one of the earliest pioneers in the Village of Manatee, married Capt. Robert Sands Warner on March 31, 1875. Captain Warner was the second son of James Warner of Palma Sola and owned the SS *Erie* steamboat. He had command of the SS *Margaret* during the Spanish-American War. The SS *Margaret* was owned by H. B. Plant, the founder of Tampa.

Samuel Sparks Lamb came to Manatee County in 1868 and founded the settlement of Palmetto. He came with his second wife and six children from Clarke County, Mississippi. His children were Julius, Mary Emma, Ellen Sarah, Margaret, Julia Elizabeth, and a son called Dool. He opened a dry goods store and was a founding stockholder of the Peoples Wharf and Shipping Company.

James A. Howze was mayor of Palmetto in 1887. This photograph was taken a short time before Mrs. Howze died from yellow fever spread by a salesman from Tampa who visited Howze's store in 1888. Howze later married Frankie A. McKay, the principal of the newly built school. He owned part of the city's dock but sold it and built his own dock with a packinghouse.

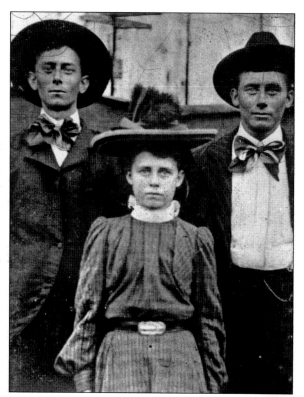

Elizabeth and Jacob Keen moved to the Duette area and purchased 160.2 acres in 1880. Later they bought an additional tract of 40 acres from Sam Mitchell of Mitchellville for $1. The property was located at the Bunker Hill Fork of the Little Manatee River. Pictured from left to right are Belonia Edgar Keen, Belvia Rosetta Keen (at age 13), and Daniel Keen. The neighboring Keene family was not related to the Keens but caused confusion when William Keene married Belvia Keen and Lela Keen married Loney Keene.

Alice Bullock Harllee, wife of Peter S. Harllee, is pictured in Palmetto. Peter followed his brother John to Palmetto when asked to bring a load of mules and horses from Texas. Alice was the niece of Sara Lee Vanderipe. The couple moved from Manatee in 1882 to start a farm north of Palmetto on McMullan Creek, ultimately becoming Manatee County's largest tomato growers.

Three friends pose together around 1895. Charles Duckwall (left) was the son of a pioneer family in Braidentown, and he was the captain of the passenger and freight boat *Mistletoe*. Willie Patten (right) built the first home on the east side of Ware's Creek and became postmaster of Braidentown in 1890. Charles Stuart is pictured at center.

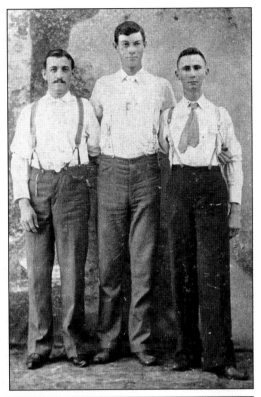

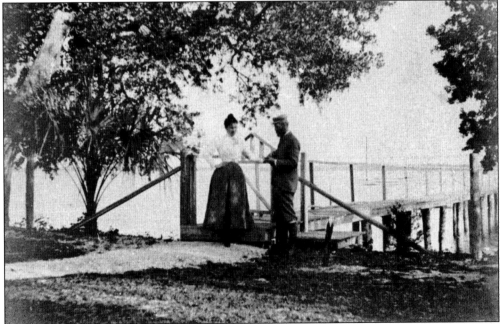

Dr. John and Jenny Leffingwell stand by their dock on the Manatee River. Dr. Leffingwell was the son of Hiram Leffingwell, one of the founders of Ellenton. He built a home on land at Curry's Point given to him by William Patten. Dr. Leffingwell installed the first telephone lines in the area, which serviced 10 customers in Braidentown, Oneco, Manatee, Palmetto, and Sarasota.

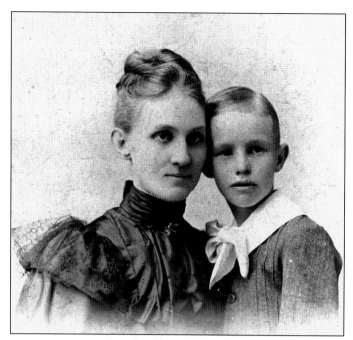

Jenny Leffingwell, the wife of Dr. John Leffingwell, is shown here with their son, Jack Banard Leffingwell. The family lived in the large home built by Hiram Leffingwell west of the Gamble Mansion in Ellenton (the site of the present-day EarthBox Center) before moving to Curry's Point. Jack assisted his father in the installation of the first local telephones and later became a historian.

Nellie June Leffingwell was born in Missouri on November 17, 1878, and was the youngest daughter of Hiram Wheeler Leffingwell, the civil engineer who purchased land from the Patten family and developed the town of Ellenton. She was an accomplished pianist and married John J. Fogarty of Fogartyville. Fogarty established the boat works on the Manatee River east of Bradenton.

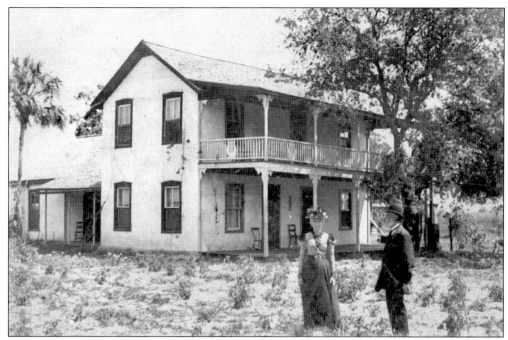

Dr. and Mrs. J. J. Dean stand in their garden at their home in Palm View. Dr. Dean was a homeopathic physician who practiced his profession with Dr. John Oliver Brown and Dr. M. B. Harrison on the north side of the river during the 1890s. The Cracker home has porches in the front and on the side to provide shade and good ventilation.

King William Wiggins was the son of John Wiggins, who moved from Pascagoula, Mississippi, in 1894. John and his wife, Virginia, purchased a store and wharf in Manatee from Capt. John Harllee. King and his wife, Lula Inez, joined them the following year, but Lula died within months. King married Mae Lillian Curry in February 1898, built a large home, and raised six children.

The children of King W. Wiggins and Lillian Mae Curry Wiggins are, from left to right, Oliver Clyde, Lillian Mae, and William Curry Wiggins. Their children who are not pictured were Wilton Curry, Ruby, and Ernest. The Wiggins family home was on present-day Fourteenth Street and Manatee Avenue.

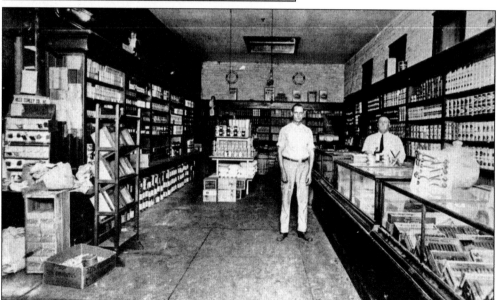

King Wiggins built a barn to accommodate the horses and buggies used on his numerous citrus groves and farms. His father died in 1923, and King assumed the store business and expanded it, including the replacement of the old wooden building with a modern brick building. This is the interior of the replacement store on the northwest corner of Manatee Avenue and Ninth Street.

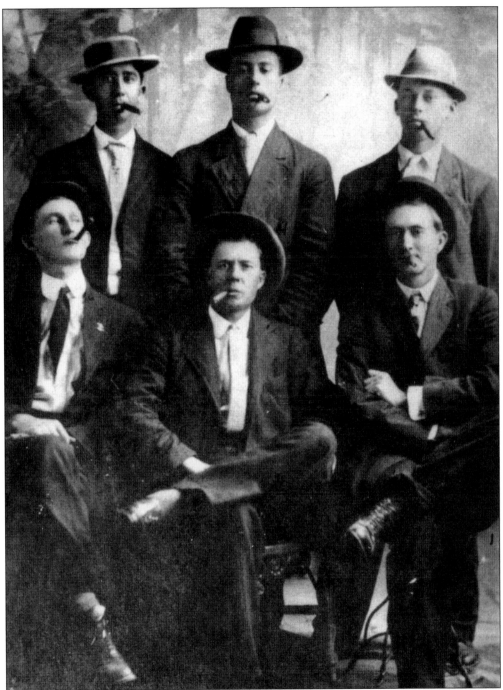

Havana cigars were always a favorite among Florida men, particularly for those who wanted to pose as big shots. These six young men were no exception. All six lived in Ellenton. According to the story, they went to Ybor City in Tampa to "ham it up" by posing with Cuban cigars in their best dress while having their picture made. Pictured from left to right are (first row) Grover Cleveland Vowel, George Church, and Sam Tyler; (second row) Joseph Garcia, J. B. Alford, and J. D. Wiggins. (Courtesy of Joyce McCook.)

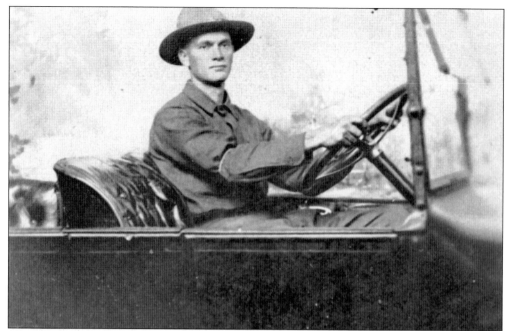

Ezra Raulerson was one of 15 children born to Carroll and Florence Keen Raulerson. The family grew up in the Dry Prairie area of Manatee County, which was commonly called "Four Corners" because of its location at the forks that drained into the Manatee River. Ezra was a member of the army during World War I and poses in a car at Duette around 1918.

Two young men are enjoying the porch of Col. Charles H. Foster's plantation home. Foster bought 580 acres of the old Braden Castle estate in 1870 from Mary Pelot. He planted a 50-acre orange grove, the largest in the county at the time. The home was built of cherry and mahogany woods and was named Fairoaks, but it burned in 1910 from a brush fire.

This *c.* 1920 photograph shows Janey Gates Griffin (center), who was the first white child born in Manatee County. She was born in 1842 to Mr. and Mrs. Josiah Gates soon after they moved to the county. The boys in the photograph are Griffin Davis (left) and Bobby Davis (right), the sons of Charles and Helen Warner Davis.

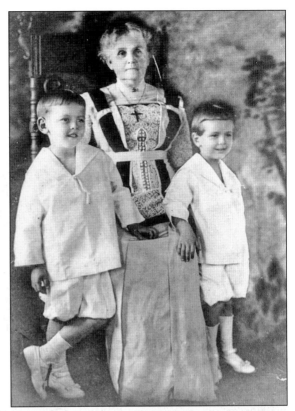

Alice Warner Barney, shown at her home, was the third child of Warburton and Helen Warner. The Warners established the community of Palma Sola. Alice married J. W. Barney, who came from Kansas City in the early 1900s. He was a gifted musician and cooperated with the U.S. Department of Agriculture in experimenting with plants and trees. J. W. and Alice's three children were Janet, Richard, and John.

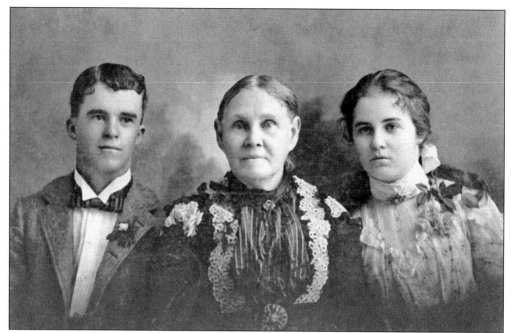

Mary Jane Wyatt Whitaker, the wife of William Henry Whitaker, poses with her grandchildren Harper Elliott Whitaker and Grace Spencer Whitaker. Mary Jane was the youngest daughter of Col. William Wyatt. William Whitaker was the father and founder of Sara Sota (Sarasota) and was a cattleman and citrus grower.

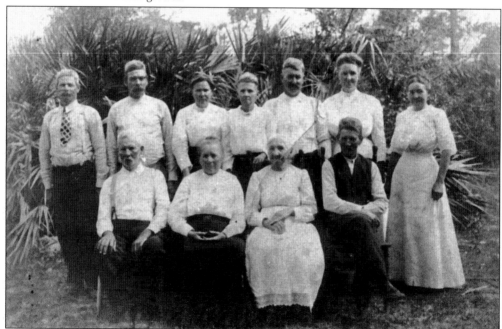

Pictured from left to right are (first row) Henry Hawkins, Caroline LeFlam, Mrs. LeFlam (Hawkins's second wife) and Jimmy Hawkins; (second row) Charles Mink, Bill Mink, Fanny Mink, Lizzie Mink, John LeFlam, Jane LeFlam, and Molly Mink. The mother's first husband was a Hawkins, the second a Mink, and the third a LeFlam.

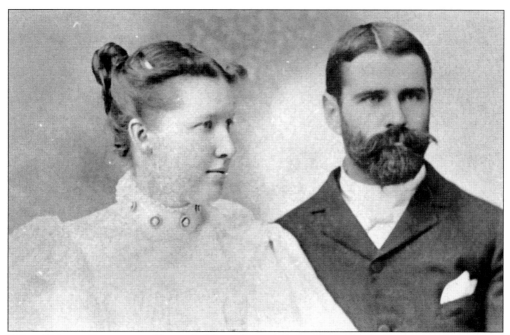

Egbert Norman Reasoner and his wife, Mary Ellen, moved to the Village of Manatee and took over the Royal Palm Nursery when his brother, Pliny, died in 1888. Egbert experimented with many plants, including tobacco. He became state vice-president for the Society of American Florists in 1908. The Reasoner nursery business thrived and continued for more than a century.

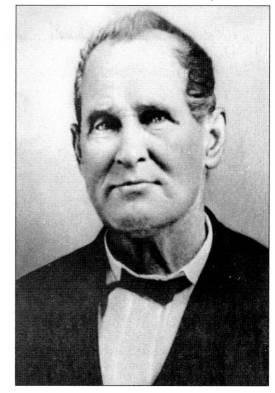

Dr. Franklin Branch moved from Tampa to the Village of Manatee in October 1846. He purchased a supply of drugs from Henry Clark's store and ran an apothecary shop. He and his wife, Vashti, had six children and also adopted a girl, Mary Fife. He moved after the death of his wife and sold his property to Capt. John Curry. No physician was left in Manatee County during the years of the Civil War.

James C. Vanderipe was an early settler in the Village of Manatee and served in Kirby Smith's division of the Confederate army. He was first married to Florida Ellen McLeod, who died. He then married Sara Lee, the daughter of Manatee settler Edmund Lee. Vanderipe is thought to have died in 1876 and is the only one buried in "the Lonesome Grave of Manatee" at Eighteenth Street and Third Avenue East.

George Emmerson Bean was the first person to settle with his family on the north point of Anna Maria Island in 1893. His son, George Wilhelm "Will" Bean, helped organize the Anna Maria Beach Development Company in 1911 and mapped out the community with streets and a water system. One of the investors was Charles M. Roser, who sold his invention of the Fig Newton cookie to Nabisco for $1 million in 1910.

Two

GROWTH ALONG
THE RIVER

It was not unusual for early pioneers to have many children, so it was natural for the descendants of early pioneers to swell the population at a rapid pace. For example, Maj. George Patten and his wife, Mary, (who purchased the Gamble property in 1873) had 13 children at the time of their arrival in Manatee County. The S. S. Lamb family, founders of Palmetto, had 16 children, and many families boasted of similar numbers. There was also a steady stream of new arrivals. The large sugar plantations ceased to exist during and after the Civil War, and large parcels of land, such as Major Gamble's 3,450 acres and Pinckney Craig's 1,560 acres on the north side of the river and more than 1,000 acres owned by Joseph Braden on the south side of the Manatee River, were divided into smaller parcels and sold.

Basic needs were met with the establishment of businesses such as packinghouses, ice plants, grocery and hardware stores, drugstores, boat works, and the opening of boarding houses and hotels to meet the needs of locals and tourists alike. Fields were plowed and citrus trees planted. Cattle grazed openly on the land with no fences, and fishermen were hauling in fish by the truckloads. Everyone seemed to prosper. Wharves were built up and down the river as steamboats plied their way to places such as Tampa and New Orleans with bounties of citrus and produce being shipped to anxious buyers. Meanwhile a spiderweb of rails was being laid. Every crook and cranny within the borders of Manatee County was soon inhabited by families working to take advantage of the opportunities afforded.

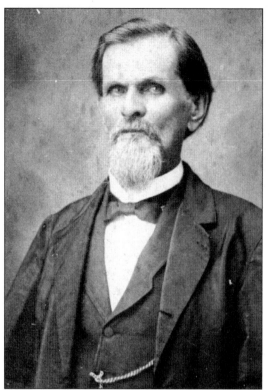

Capt. John William Curry was the son of pioneer Capt. John Curry, who came with his family to Manatee from the Bahamas in 1860 with his wife, Elizabeth, and two children. Captain Curry was appointed provision-master under Capt. John McKay of Tampa to keep Confederate troops supplied with beef during the Civil War. The Curry family became one of the largest and most influential families of Manatee County.

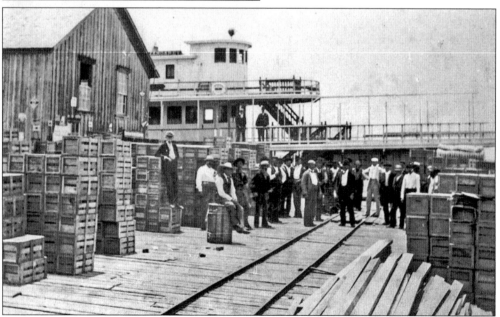

Men are waiting to load boxes aboard the steamboat *Margaret* at Joel Hendrix's dock, which was located at the end of present-day Eighth Avenue in Palmetto. The boxes were likely filled with citrus, since Joel Hendrix had planted a grove that had reached maturity by the time this photograph was taken in 1895. Hendrix was Palmetto's first postmaster, because the post office was at the dock until it moved to the home of J. W. and Mary Nettles.

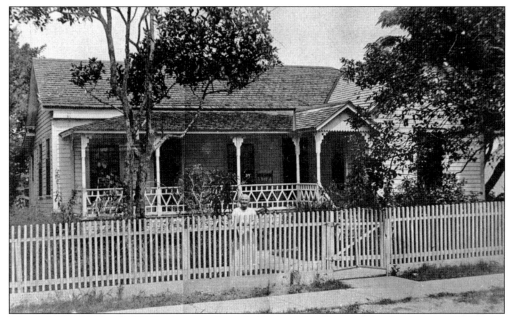

Mary Nettles, wife of J. W. Nettles, stands at the fence in her front yard at her home in Palmetto. She built a building adjacent to her home that became the post office when it was moved from Joel Hendrix's wharf in 1880. The building was later moved by the Palmetto Historical Commission and is part of the Palmetto Heritage Village. The village offers visitors a glimpse into Palmetto's past.

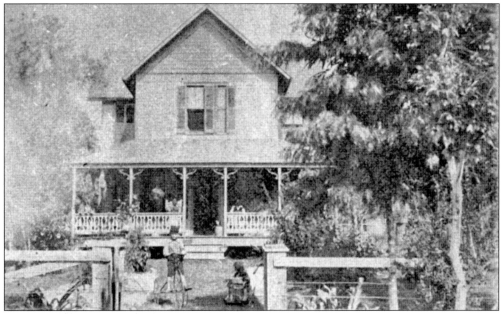

Unidentified children play in the front yard of W. B. Thompson in Oneco. Thompson settled at Orange Ridge, bought part of the old J. M. Helm grove, and in the early 1890s raised citrus, potatoes, tobacco, and watermelons. He was a trustee of the Oneco School and opened a packinghouse in 1899. In 1906, he bought the Day family home in Bradenton and became a stockholder in the Bradenton Bank and Trust.

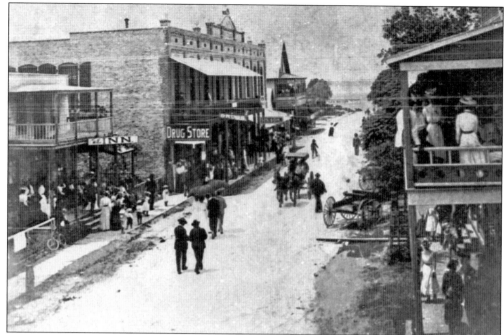

Wagon ruts on Main Street in Bradenton were common, but shell rock was added by the time this c. 1902 photograph was taken. People gather on the porch of the Gaar House Hotel (upstairs on right) as two mules pull a buggy down the middle of the street. A group of people (left) crowd together on the porch of the inn near Stanfield's Drug Store.

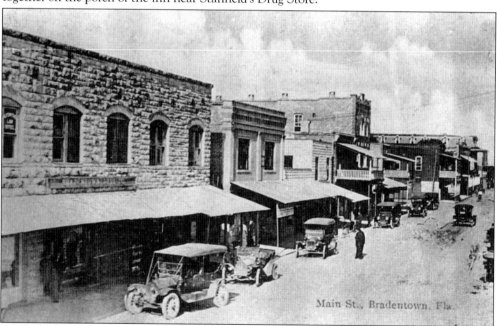

This c. 1912 photograph shows the changes to Main Street in Bradenton. Automobiles are now parked on the shell paving of the street. Many wooden buildings have burned, and some buildings are now made of brick and have awnings to cope with the sun and rain. The long roof of the Manavista Hotel can be seen in the far background.

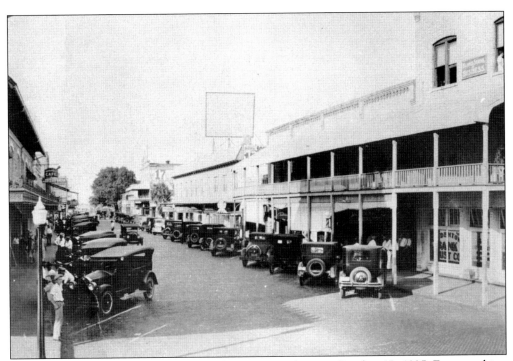

This photograph of Main Street in Bradenton was taken on October 13, 1925. Every parking space is filled with automobiles in front of the stores. By this time, all of the stores are made of fireproof brick or cement block. There are also crosswalks and street lighting.

An unidentified boy with a bicycle and a man stand on Cedar Avenue in Palmetto looking north from the Howzes' home. The nice house has an ornate porch and a long, sturdy, wooden fence out front. The only families living on Cedar Avenue in 1900 were those of M. O. Harrison, S. A. Howze, and E. B. Collins, who bought the former Whittle home.

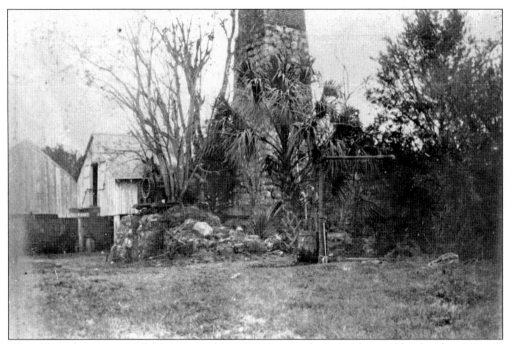

The old Braden Sugar Mill lay in ruins by 1900. Dr. Joseph A. Braden and his brother, Hector, left Tallahassee in 1842 after the collapse of the Union Bank and built their fortress home called the Braden Castle. Hector drowned while crossing Little Manatee River in 1846. Joseph owned more than 1,000 acres between the Manatee River on the north and the Braden River to the east, but he left the plantation in 1857.

Capt. William "Bill" Stanton was the son of Samuel Stanton, who built the side-wheeler steamboat *Manatee*, which was launched in August 1884. (William's brother Samuel Ward Stanton drowned with the sinking of the *Titanic* on April 14, 1912, and another brother, Curtis, helped build and install the engine on the *Manatee*.) The family had a thriving sawmill on the Manatee River.

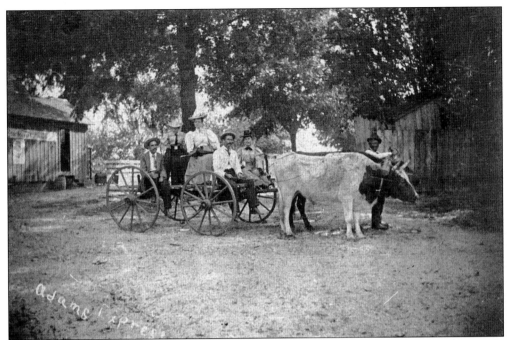

The Trueblood family poses for a photograph in a cart driven by two oxen. Because the picture was marked "Adams Express," it is thought to have been taken at the Villa Zanca estate, which was owned by Maj. Alden J. Adams. Adams owned 300,000 acres at one time and built a 16-room castle. Adams's farm included many animals and enticed many visitors.

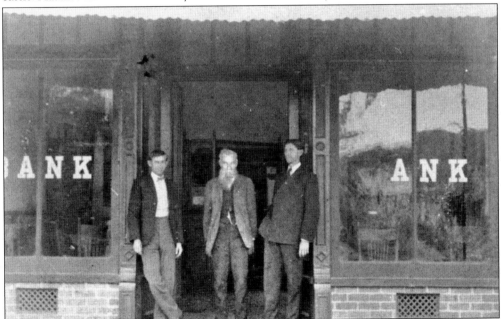

Three men stand in the doorway of Palmetto's Manatee County State Bank. Picture from left to right are Thomas A. Howze, S. S. Lamb (the founder of Palmetto), and Asa M. Lamb (one of 16 children raised by S. S. Lamb and his second wife, Sarah McLeod Lamb). The bank was the first brick building in Palmetto.

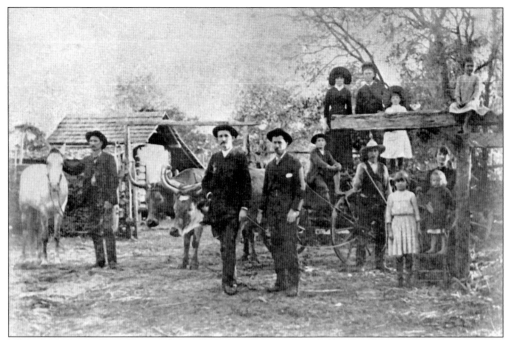

This photograph shows Garrett Murphy (next to the oxen) and his family posing at their Myakka ranch with a large wagon drawn by two oxen.

Mr. and Mrs. Garrett ("Dink") Murphy pose with their family at Myakka. Pictured from left to right are (first row) A. B. Murphy (Dink's son), Dink Murphy, and judge Sam Murphy (Dink's son); (second row) Holly Murphy Cornwell, Louise Murphy Tallevast, Francis ("Fannie") Pearce Murphy (Garrett's wife), and Martha Lee Murphy Gaar; (third row) Nell Murphy Painter, Daisy Murphy Tabor, and Josephine Murphy Johnson (all three daughters of Dink).

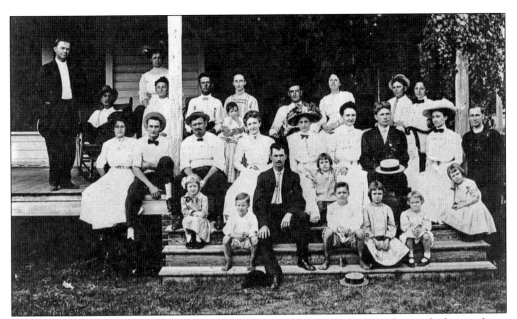

Like most families, the Murphys grew quickly. Pictured here are the Murphys with their in-laws. This c. 1905 photograph was taken at the family's Bradenton home instead of at the old home in Myakka. Dink Murphy owned the Livery, Feed, and Sale Stable in Bradenton. He promoted real estate sales and also furnished guides with dogs for hunting and fishing parties. Murphy's friend S. V. Harris operated the local blacksmith shop.

John Waddell Harllee poses with four of his sons. Pictured from left to right are Horace, John, John W. (seated), William (sitting in John W.'s lap), and Andrew. Andrew and John moved to Manatee Village from South Carolina in 1868 to help their cousin Marie Brady. Brady's parents had died from yellow fever, and her husband fell from a boat and drowned.

Erasmus Rye was the husband of Mary Lucebia Williams Rye and the founder of the Rye settlement. In 1861, Erasmus acquired land at Oak Knoll on Gilley Creek. After five months of marriage, he and his father-in-law, James Williams, joined the Confederate army. Erasmus was wounded and was held as a prisoner of war for three years. He and his wife later acquired the Williamses' 119.58 acres.

Sixteen-year-old Tekia Maude Adams is pictured with her father, Maj. Alden J. Adams, and her maternal grandmother, Mary Davis Pillsbury, of Palma Sola. Major Adams moved to Manatee County in 1876 after serving in the Union army and bought 400 acres, which later expanded to 300,000 acres. He and his wife, Adelaide, built a 16-room concrete castle called Villa Zanza. He was the nephew of John Adams, the second president.

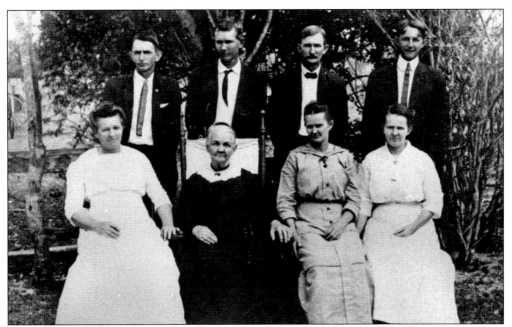

The Pope family of Braden River pose together. Pictured from left to right are (first row) Molly Pope Hall, Melinda Ann Frances Cason Pope (wife of Andrew Jackson Pope), Lena Pope Johnson, and Lucy Pope Young; (second row) George Dallas, John, A. C., and Augustus. The Popes had 13 children; two died in Georgia. Andrew died on December 4, 1908, and Melinda died of typhoid fever in 1915.

Mara Harris (standing) and Lizzie Lyle (seated) pose with Henry F. Curry's buggy and its driver. Henry moved from Key West in 1882 and purchased 12 acres of land in Bradenton from William Patten on which he built a large riverfront home. The area became known as Curry's Point and later became Point Pleasant. Patten gave Dr. J. B. Leffingwell of Ellenton an adjourning lot.

The Wallace family gathers on the porch of their large home in Bradenton at 609 Prospect Avenue (later Fifteenth Street West). Seated on the porch are Mrs. Wallace with the newborn baby, her mother, and four of the seven children. George B. Wallace stands near the steps. He and G. A. Nash owned an exclusive dry goods store that specialized in ladies' dress goods.

The Henry Franklin Curry family shows off their new one-cylinder Cadillac, the first car in Bradenton. Whitney "Whit" Curry, a son, is the driver, while his brother, Edison, sits in the back with his mother. The car was delivered to the Corwin Dock, and Whit attempted to drive the car off the dock but had to be pushed up the steep incline by spectators. Whit and Edison later founded Curry's Garage and Machine Shop.

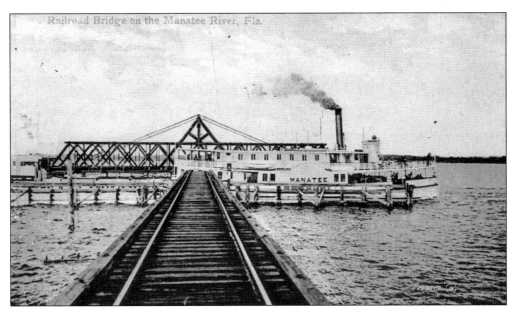

The Seaboard drawbridge across the Manatee River opens to allow the steamboat *Manatee* to pass. This *c.* 1908 photograph was taken when railways were beginning to compete with the steamboats. The Tampa Southern Railroad became the Atlantic Coastline Railroad. It later merged into the Seaboard Airline Railroad to become Seaboard Coastline Railroad and ultimately Seaboard Systems, Inc.

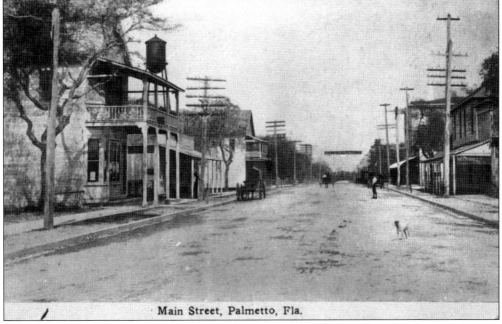

Main Street, Palmetto, Fla.

This is Main Street in Palmetto in 1905. A lone man and a dog stand on the deserted street as a horse waits with its buggy. Another horse-and-buggy are approaching in the distance. Poles line the streets to provide electricity, and a tall water tower looms in the distance. The town was founded and named Palmetto by S. S. Lamb, who had fond childhood memories of South Carolina, the Palmetto State.

Manatee Avenue in the Village of Manatee is much like other city thoroughfares in 1905. The streets are sandy and marked by many potholes. The potholes are deep on the left along the palms and walkway, likely caused by heavy rains and flooding. An ox team on the right is trying to make headway through the sand. Another wagon is parked on the left as a man strolls down the walkway.

Blacksmiths were necessary during the early years but were needed less with the advent of the automobile. In this c. 1905 photograph, H. Watts Ethridge poses with his wife, Mary, in front of his home in Parrish. He and his brother, Orville, owned and operated the blacksmith shop, which was always busy with customers when horses were the major means of transportation.

Ed Pillsbury of Palma Sola was the brother of Asa Pillsbury. He married Lorena Courter from Palmetto, and they lived for years in Fogartyville while he operated the schooner *John Fogarty*. He later became a keeper of the two beacon lights at the mouth of the Manatee River and was paid $30 a month. Ed and his four sons opened the Snead Island Boat Works in 1907.

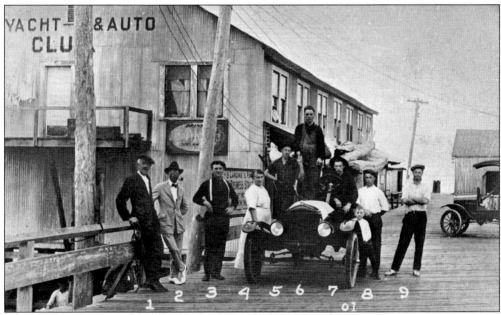

The Yacht and Auto Club building was on the west side of Manatee River's Corwin Dock, which jetted out from the foot of Bradenton's Main Street. It was built by Claude Shaver, who housed his Ford Automobile Agency on the first floor. The man in the white suspenders is Edison Curry. He and his brother, Whitney Curry, won the Tampa-to-Bradenton Auto Race. The man on the far right is Everett Hawker. The others are unidentified.

Dr. F. H. Braymer poses with his family on the front porch of their home in Bradenton. Rocking chairs and a hammock suggest a life of leisure, but Braymer worked hard on his celery farm. Pictured from left to right are Clarence Braymer (son), Dr. Braymer, Marian Braymer (daughter), and Mrs. F. H. Braymer.

Judge A. T. Cornwell poses with his Cadillac in 1912 next to his wife in front of his home while the grandmother sits in the back with her three granddaughters. Cornwell was elected mayor of Bradenton in 1904 and later became a judge. He built several cottages on Anna Maria Island before the Cortez Bridge was opened, and he was a leading citizen in Manatee County.

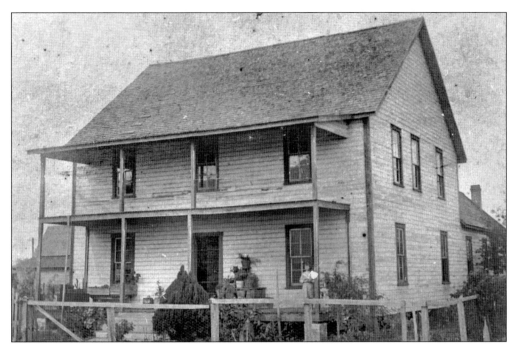

There were boardinghouses scattered across the county in the early 1900s because of the growing demand for laborers on the farms and groves. The child in this c. 1913 photograph stands on the porch of the Ethridge Boarding House in Parrish, which was built in 1900. It was owned by Steven H. Ethridge and his wife, Mary Ann Freeman Ethridge, who also owned the Ethridge Meat Market.

Pictured from left to right at the 1915 Harris Holland family reunion are (first row) Mildred, Leila, and Hubert Collins; Wilton Edwards; Elda Holland; and Ruth Collins; (second row) Stella, Mont, and Earl Whidden; Jewel Edwards; Eva and Florence Whidden; Van Edwards; and Clarice Johnson; (third row) Addie Johnson (holding her son Warren); Grayston Johnson; E. Holland (holding his daughter Maude); Watus Holland; Oden Edwards; Ellender Edwards; Harris Holland; Saxon Whidden; Amanda Holland; Susan Whidden; and Cynthia and Leon Collins.

Charles Lucien Richards, called Lu, was the son of Daniel and Nancy Elmira Gillett Richards. Lu was the grandson of Daniel Gillett. Daniel was born in 1810 in Georgia and was a veteran of the Second Seminole War. Daniel and his wife, Molly Mariah Hare Gillett, were the original settlers of the Frog Creek area that was later named Gillette in their honor.

William (left) and Julius Richards (right) were the sons of Daniel Uriah Richards and his second wife, Mary Emma Lamb, daughter of S. S. Lamb. Their grandfather was Daniel Gillett, the founder of Gillette. William joined the navy, and Julius joined the army. Both served in World War I.

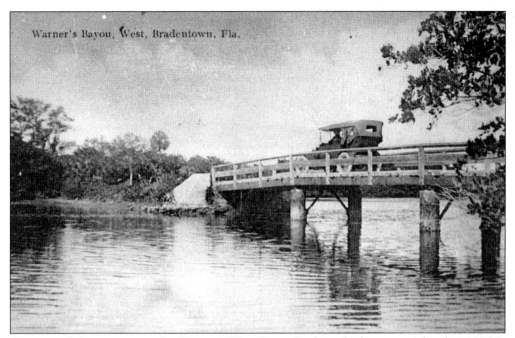

An automobile crosses over the Warner's West Bayou Bridge, which was completed in 1886. It was 752 feet long, built on pilings of green pine logs, and raised in the middle to allow larger boats to pass underneath. The estimated cost was 50¢ per foot, but Johan Willemsen persuaded the county to spend 75¢ per foot at a total cost of $840.

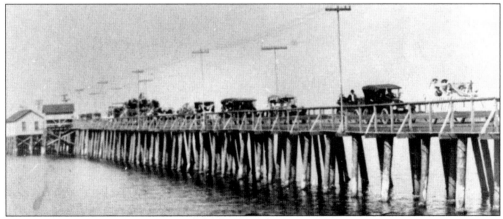

Automobiles parade across the Victory Bridge, which joined Palmetto and Bradenton. Construction on the bridge began in October 1918, and it was opened for travel in August 1919. E. W. Parker was awarded the contract, which required the use of 37 tons of steel. Harry Wadham, the construction engineer, died two years after the opening. The bridge was named to honor the victory of the United States in World War I.

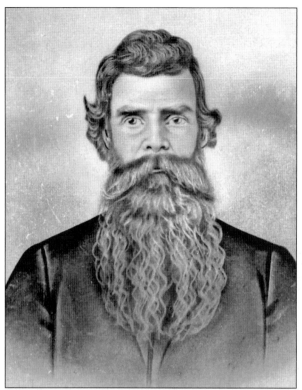

Levin Powell Johnson, son of William H. Johnson, came with his family from Alabama in 1850 and married the widow Mary Hays. Their children were Maurice, Morgan, and Helen. Mary inherited land from her husband, Lambert Hays, and divided it among her children. Leven owned several groves and bought large herds, which grazed on open land stretching from the Manatee River to Venice. He died on July 29, 1881.

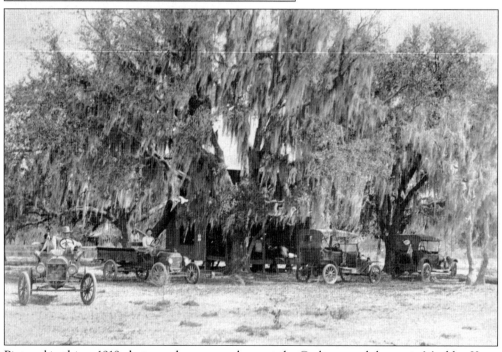

Pictured in this *c.* 1918 photograph are several cars at the Carlton ranch house in Myakka. Years earlier, this scene would have likely shown cow hunters on horses. Even at this time, open ranges still required the use of horses for rounding up cattle.

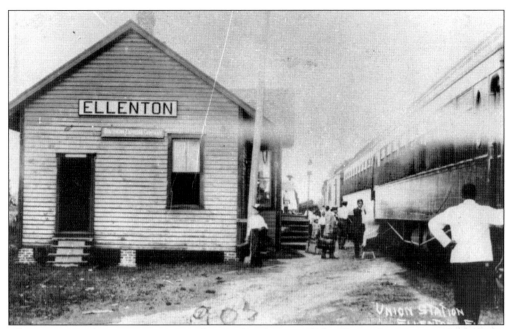

Ellenton was a thriving community during the 1890s, and the Union Station was always busy. Trains not only transported passengers, but also served as an important means of moving farmers' produce to northern markets. A tomato processing plant later replaced the Ellenton train station and provided juice and food for members of the armed forces during World War II.

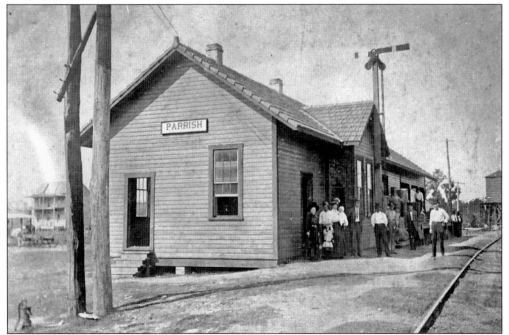

The Parrish Seaboard Airline depot was extended beyond Ellenton and served the needs of travelers, farmers, and citrus growers. This c. 1920 photograph shows people standing on the shady side of the train station, apparently waiting for an approaching train. Note the water pump in the left foreground and the building in the background, which was possibly a boardinghouse.

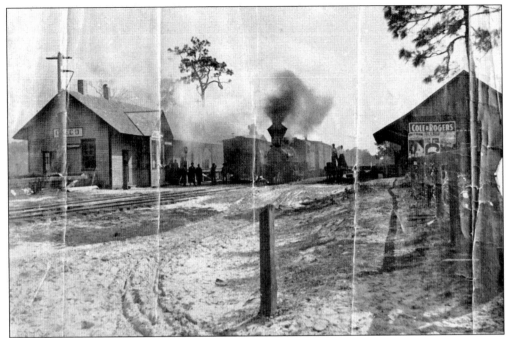

This photograph of the Oneco railway depot was damaged by folding but still shows a several of the buildings on both sides of the track as a steam locomotive appears to be leaving with attached boxcars. One side was likely used by passengers and the other for stacking, loading, and unloading citrus and produce.

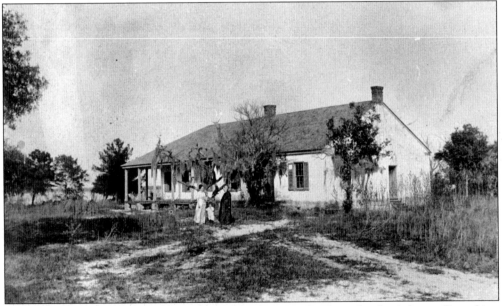

The Fulmore-Brady home on Jacques Creek later became the depot for the Atlantic Coast Line Railroad. The combination store and home was begun by Col. and Mrs. Joseph R. Fulmore, their daughter, Marie, and her husband, Francis Brady. The Fulmores died from yellow fever in 1867. Francis bought an additional 160 acres in Palmetto but fell off a steamboat and drowned. Marie sold her mercantile business and property in Palmetto to John Harllee.

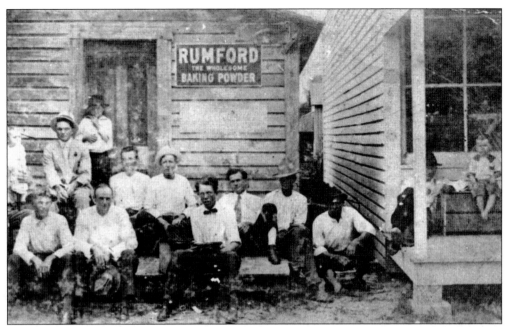

A group poses in front of W. H. Brown's store in Ellenton underneath the Rumford Baking Powder sign. Pictured from left to right are (first row) Jesse Wiggins, L. S. Hardin, and Austin Christie; (second row) unidentified, Clive Garcia, unidentified, Hugh Nichols, Clyde Wood, Bud Matthews, Ray Patten, Joe Fischer, and Fant Johns.

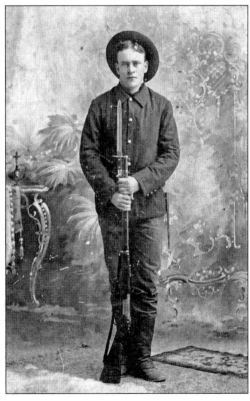

Germain Hanstead Wyatt of the Village of Manatee poses in his uniform with his rifle in 1898. He fought in Cuba during the battle of San Juan Hill and survived yellow fever, despite the fact that he was erroneously reported dead. Hans was the brother of Mary Jane Wyatt Whitaker, and he married Mary Fife, the adopted daughter of Dr. Franklin Branch. He later became the sheriff of Manatee County.

In 1909, Emmett Patrick Green Jr. left Marietta, Georgia, with his family and opened the Cortez Hunting and Fishing Club. He purchased much of Cortez Beach, whose name was later changed to Bradenton Beach. He was elected to the Bradenton City Council and was a member of the Florida State Road Department. He started a campaign to replace the old Victory Bridge, and the new one was named after him.

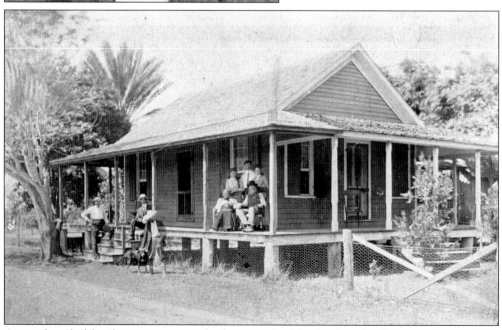

An unidentified family group poses on the front porch of the first boardinghouse in Oneco, while a group of men stand or sit near the front steps. Boardinghouses were located in almost all of the communities in Manatee County and supplied workers for groves and farms. Seasonal packinghouses always needed a large number of workers for culling and boxing citrus and produce.

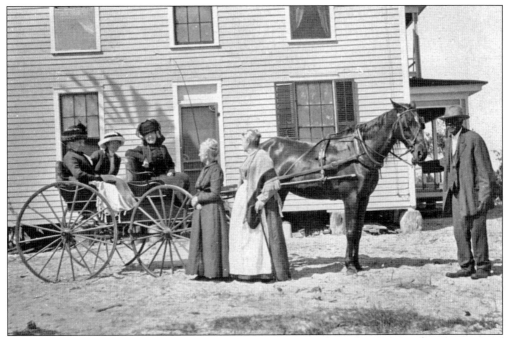

Two ladies (standing) visit with three ladies seated in a buggy outside of the Bradley House Hotel in Palma Sola, formerly known as the Warner Hotel or Palma Sola Hotel. The hotel was built by Warburton Warner on McNeil Point in 1884, and Palma Sola prospered for about 10 years. It was purchased from Warner by Cecile and Al Bradley, but the hotel slowly deteriorated and was ultimately torn down in the 1920s.

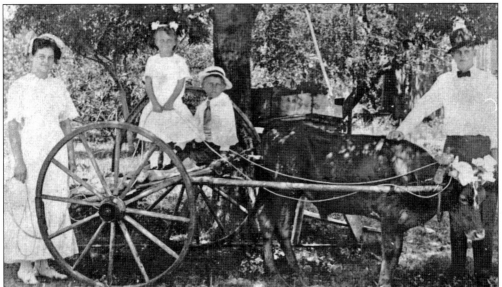

These are the children of D. S. "Sanders" and Lula (Bozeman) Fulford. Pictured from left to right are Catherine, Clarene, and John. The man at right is unidentified. Sanders was one of the original five pioneer settlers in Cortez. He arrived with his brothers, Billy and Nathan. Sanders operated the Fulford Hotel and fishing operations on the Cortez docks. The property later became the site of the Cortez Trailer Park.

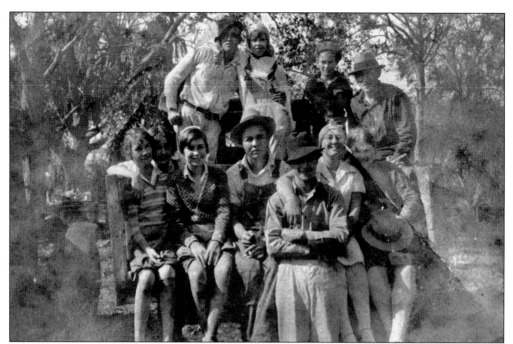

A happy group sits in the back of a pickup truck at Cortez on January 30, 1930. They are, in no particular order, Toodles Adams, Grey Fulford, Paul Williams, Pauline and Howard Adams, Hazel Johns, Thelma Pringle, Nellie Mae Williams, Bill Rutenschoex, and Floy Taylor.

Two automobiles are parked at the front entrance of the arcade and post office building in the Village of Manatee. The building was 110 feet by 110 feet and was made of hollow stucco tile with a tower on the corner. The architect was J. H. Johnson, and it was owned by the Manatee Arcade Company, a group composed of local businessmen and investors. It had a drugstore, a grocery store, and an insurance office.

Pictured next to the Manatee River with signs pointing to Dr. Charles Larabee's and Albert V. Huyler's homes, are, from left to right, (kneeling) Charles Hampton; (standing) Percy Hampton, Al Roberts (behind), Twinnie Ezell, Doris Hampton McLaughlin, Lizzie McLaughlin Cason, Margaret Heusindveldt and Emmet Cason. Hampton died while fighting in World War II.

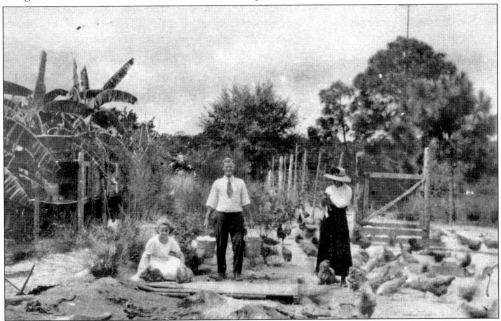

Rural families had a variety of food sources. Shown here is the McLeod family with their chickens and fenced-in banana patch. This area was across from the family farm on Fourteenth Street in Bradenton. Norman McLeod is standing with the feed buckets, and his wife, Oma, is holding a chicken. Their daughter sits with a pet rabbit.

Elizabeth "Libby" Crews, shown here in 1938, is the great-great-granddaughter of Daniel Gillett and the granddaughter of Nannie Richards Stewart and judge James Jones Stewart. Libby married Joe G. Warner, a cattleman, and spent time in the saddle working with her husband on the ranch. Libby was an avid historian and assisted her husband in the writing of *Biscuits and 'Taters'*, the story of cattle ranching in Manatee County, published in 1980. She also assisted in the writing of *The Singing River*, a detailed history of growth along the Manatee River, and is an active member of the Manatee County Historical Society.

Three

FARMING, FISHING, AND MAKING A LIVING

The needs of Manatee County's residents were no different from that of other folks who migrated to Florida. Making a living was the primary concern of everyone. The early settlers in the Village of Manatee immediately set about to build temporary shelter, followed by clearing land for the planting of gardens and building pens for their animals. Primary needs were essential for survival, and no one was immune to the hardships that had to be endured. Wells had to be dug, and the bare necessities of life, such as food, water, and shelter, had to be provided. Stockades were also erected for protection from Native American raids.

But it was not long before man's ingenuity and entrepreneurship surfaced, prodding settlers to begin their trek toward lifetime professions. Blacksmiths were already in demand. Health services called for physicians; legal services required attorneys; mercantile and hardware stores sprang up; banks opened; hotels welcomed tourists; and businesses were soon catering to the whims and needs of everyone. Farmers cleared land and planted crops while cattlemen expanded their herds and acreage. Fishermen discovered the abundance of seafood, and citrus growers planted and waited patently for their first harvest.

Making a living in Manatee County came readily for those willing to work hard. Few places in Florida offered such an abundance of opportunities for financial growth and stability, opening up a vast array of resources needed to meet the needs of a growing population. The extension of railroad networks beyond Tampa replaced the antiquated and romanticized flotilla of steamships plying the waters of the Manatee River, and life moved on as klaxons replaced reins and rutted streets were paved.

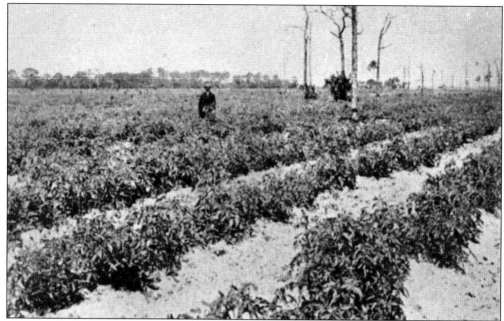

Tomatoes became the county's major crop. These were grown on sandy soil at Terra Ceia in the early 1900s. J. A. Howze and J. N. McLean built the first packinghouses at the end of Palmetto Pier, and Lonnie Sims joined with McLean to build another at the foot of the wharf. Pope Harllee formed Harllee Farms in 1935 with his two sons, Peter S. and J. P. Jr.

Employees gather for a photograph on the Palmetto Pier at the packinghouse built by J. N. McLean and J. A. Howze. Pictured from left to right are (standing) Lonnie Sims, Felix Tate, Tom Howze, J. Pope Harllee, and Capt. J. A. Howze; (kneeling) J. N. McLean with an unidentified child. A sign advertising Coca-Cola hangs in the background. Citrus and produce were still being hauled by steamboat to northern markets before the advent of shipping by rail.

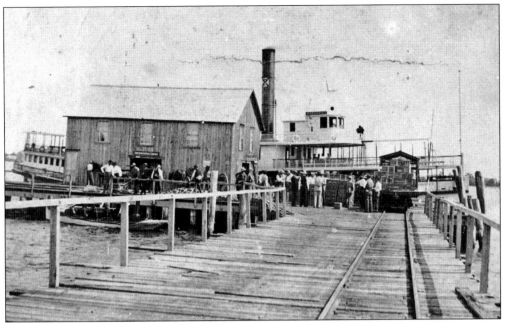

Produce is waiting to be loaded at the Palmetto Pier. The steamboat *Margaret* and the workers seem to be idle. The Palmetto Terminal Railroad had a 36-inch narrow gauge line that went to the end of the dock owned by J. N. McLean and J. A. Howze. The small launch in the foreground was a naphtha launch, the first gasoline-propelled vessel on the Manatee River. Robert Russell and George Breeze were the owners.

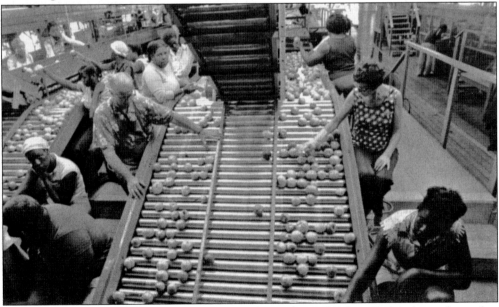

Workers sort tomatoes on the conveyor belt at the Taylor and Fulton Packinghouse located at 932 Fifth Avenue West in Palmetto. Jack Taylor Jr. founded the packinghouse. He managed the Palmetto State Farmers Wholesale Market, built by the WPA in 1937 during the Great Depression, and was the auctioneer. Peter Fulton, a tomato buyer, had a stall in the market and teamed up with Taylor, who introduced the use of cardboard packing.

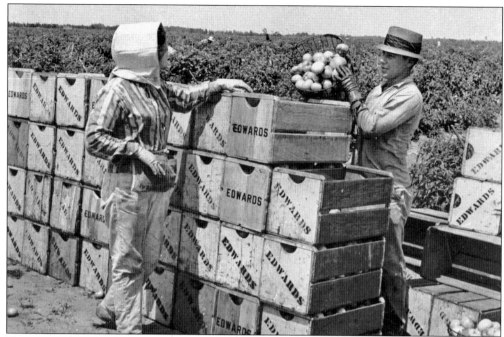

Tomatoes are poured into crates at the farm of Clarence Edwards. The farm was on the east side of the Ellenton-Gillette Road north of the cemetery and the Gamble property. Edwards was joined in the business by his son, Warren, after his return from the army. A much larger acreage was later farmed on the south side of Manatee River.

In this *c.* 1919 photograph, A. I. Root shows off his electric automobile at his residence on Richland Avenue in Bradenton. His granddaughter stands alongside the car, which appears to be filled with several baskets of tomatoes. Root appears to be dressed in his Sunday best. At the time, it was not unusual for men to be overdressed with ties and coats even when digging worms or fishing.

An unidentified quarter-acre field of strawberries is tucked among pine trees in a plot cleared for farming in the old Manatee River Park subdivision. It is recorded that this plot yielded 276 quarts of strawberries in the first two pickings. Such plots were part of the trend toward "truck farming" for which Manatee County was famous. Truck farming meant that everything raised could be hauled to market in the farmer's truck.

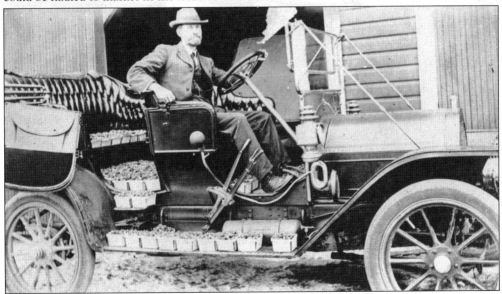

E. B. Rood delivers strawberries in style with baskets placed on the running board, floor board, and back seat of his fancy car. Hats, coats, and ties were often worn by manual workers, and Rood likely wanted to make a good impression on potential buyers. His farm was on Fourteenth Street in Bradenton, which quickly became the major highway linking Bradenton with Sarasota.

Celery was a popular crop grown in Manatee County in the early 1900s. This farm was on Fourteenth Street West (U.S. 41) in Bradenton and was owned by Wilkes McLeod. The celery was staked to insure straight stalks, and sometimes boards were placed along the rows to protect the stalks from the sun. One of the largest celery farms was Curry's Celery Farm at Manatee Hammock.

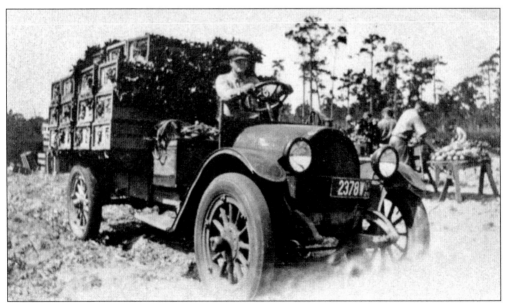

A truck hauls crates of celery from the field at Lemuel Griffin's farm in the Village of Manatee in 1920. Note the simple license plate with large numbers. The truck likely transported the load to waiting boxcars to be iced down and shipped to northern markets. Railway shipments quickly replaced cargo previously hauled by steamboats.

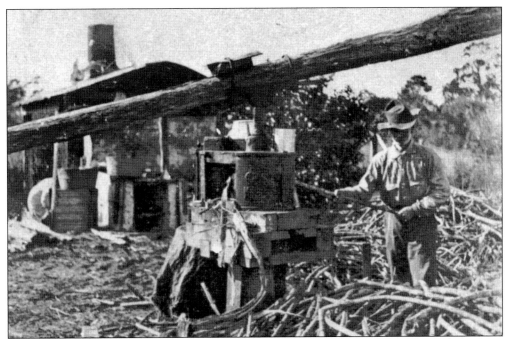

Not all sugarcane production ended with the close of the major plantations after the Civil War, such as that of Robert Gamble and Pinckney Craig on the north side of the Manatee river. Other farmers continued to grow sugarcane, which was used primarily for local consumption. Norman B. McLeod Sr. is shown here putting sugarcane in his grinder at his Bradenton mill in 1918. Children grew up chewing on sweet sugarcane.

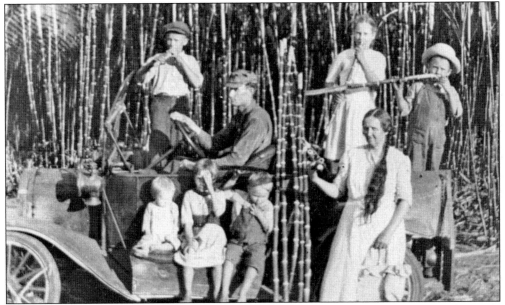

Members of the James A. Felts family gather to harvest sugarcane. Pictured from left to right are (first row) James, Idell Meinda, and Otis Felts with their mother, Melinda Idell Felts; (second row) Frank Felts, Mr. Ferguson (the driver), Beula Ward Fields, and Herman Felts. Felts helped establish the Palma Sola Wharf Company in 1908.

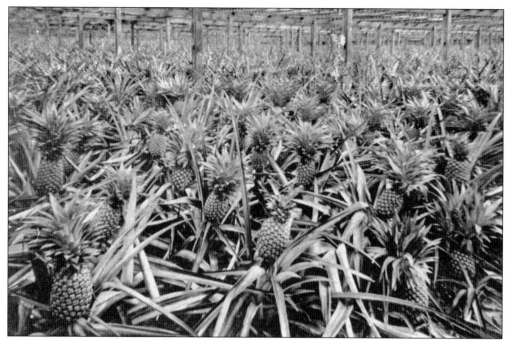

Pineapples were a major crop in Manatee County, as shown in this c. 1910 photograph; however, the competition with Cuba meant lower prices and, eventually, the venture failed. These pineapples were grown in the shade house of the Pollard Pinery in Palmetto. Talbot Pollard arrived in Palmetto from Indiana in 1895 with his wife and children and purchased land near the Manatee River on Fourth and Seventh Streets.

Artesian wells provided water for most of the farms and groves through the early 1900s. An unidentified worker stands next to the artesian well at the Hendrix grove. Joel Hendrix and his wife, Martha Ann, paid S. S. Lamb $100 for six acres on the Manatee River where they built a home and general store. In 1864, they built the first commercial wharf in Palmetto.

Robert B. Whisenant of Palmetto was one of the most innovative farmers in Florida. Born in Cuba in 1903, Whisenant attended the University of Florida and majored in civil engineering. He was posthumously inducted into Florida's Agricultural Hall of Fame for low-density row farming, a special design of floodgates, and for being the first farmer to practice seepage irrigation in tomato fields. He and his wife, Emma, had five children: Joyce, Blake, Kaye, Phyllis, and Sally. (Courtesy of Sally Whisenant Bustle.)

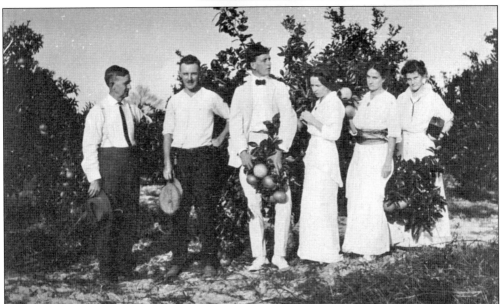

Florida citrus has always been of interest to tourists who enjoyed picking fruit themselves. This group poses in front of the orange grove on the property of the Bradley House Hotel in Palma Sola. The man on the left is probably the proprietor, and the man next to him with the hat is a worker.

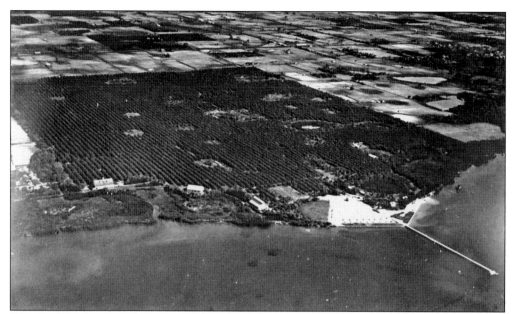

The Atwood Grove was the largest grapefruit grove in the world. Kimball C. Atwood visited the area between Ellenton and Palmetto in 1890 and purchased a 2,645-acre site, which soon had its own post office named Manavista. Pipes for irrigation were laid along 96 miles of trees laid out in straight rows. This aerial view of the grove, which bordered the Manatee River, was taken between 1918 and 1925.

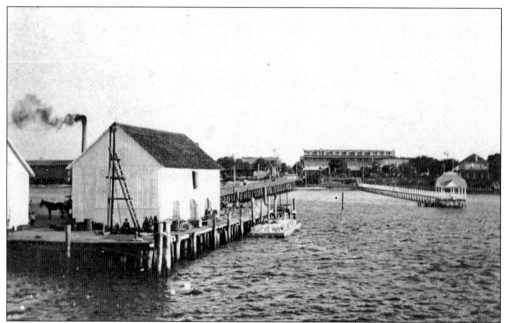

The Corwin Dock was important as a major loading wharf for citrus and vegetables because it connected with the Atlantic Coastline Railroad in Tampa. It required four hours of travel by major steamboats from Tampa to reach the wharf in Bradenton. The larger steamers also made regular trips to Havana, Cuba, and Mobile, Alabama. In this *c.* 1912 photograph, the Manavista Hotel and its dock can be seen in the distance on the right.

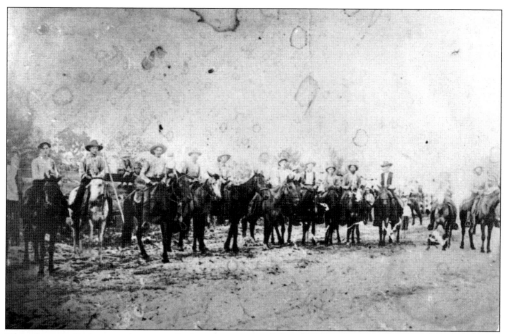

This damaged vintage photograph shows a group of Cracker cow hunters (never called cowboys in Florida) getting ready to round up cattle when rangeland was open for grazing. The view is either from Myakka or possibly a site near Shaw's Point.

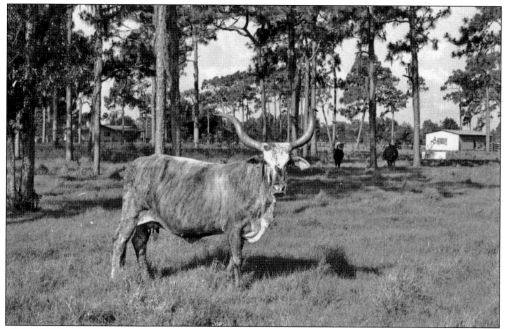

This 30-year-old long-horned cow belonged to Joe Warner, whose ranch was on the upper Manatee River. It definitely shows its Spanish heritage. There is no record that indicates Hernando de Soto brought cattle when he landed at Shaw's Point in 1539, but records do show that more than 200 heifers were introduced to St. Augustine before 1600 and that a herd of 20,000 cattle existed in Spanish missions.

Eliza Burts Vanderipe sits stoically with two of her grandsons, Van Andrew and William III. Each child in the family was given all the calves born in the year of their birth. Eliza's husband, Capt. William H. Vanderipe, received one doubloon ($15 at the time) for each steer shipped to Cuba. He died in 1901, but the cattle business continued.

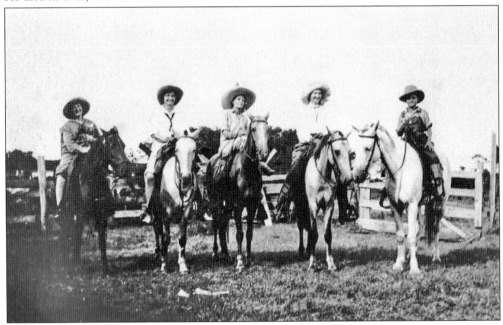

The Murphy clan is on horseback at their ranch in Myakka. These five are the four daughters and one granddaughter of Fannie and Garrett "Dink" Murphy. Pictured from left to right are Louise Murphy Tallevast, Nell Murphy Painter, Martha Lee Murphy Gaar, Daisy Murphy Tabor, and Frances "Jim" Murphy (the granddaughter).

Joe Warner shows off his Florida cow pony, Greasy, to Mrs. G. S. Warner and her grandson, Joe Mulloy, in 1937. Joe was a "cow hunter" (Florida's version of a cowboy) and the author of *Biscuits and 'Taters'*, a history of cattle ranching in Manatee County. He was also the author of *The Singing River*, a history of the families who settled along the shores of the Manatee River. He was assisted in his work and writing by his wife, Elizabeth "Libby" Warner.

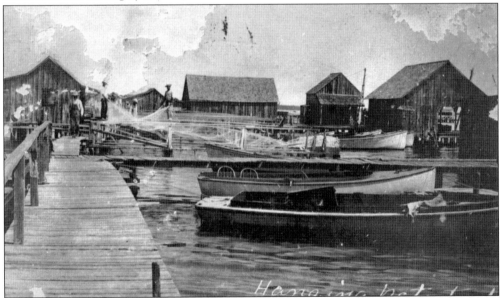

Would-be fishermen quickly recognized the ideal location for commercial fishing at Cortez, and it quickly became the heart of the fishing industry in Manatee County. Boats in the photograph have already been unloaded of their catches, and now the fishermen must dry their nets. Mullet were the target for most fishermen, using gill nets to trap the fish. These docks were all destroyed in the 1921 hurricane.

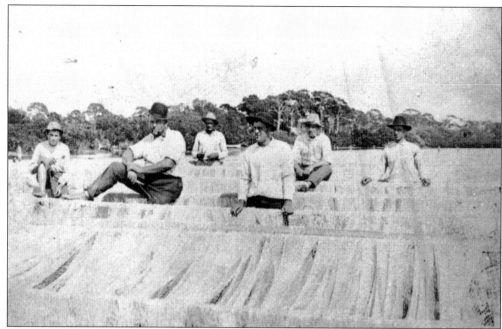

In this *c.* 1905 photograph, Cortez fishermen spread their fishing nets to dry before the advent of synthetic netting, which no longer required such attention. Pictured from left to right are Clayton Fulford, Ambrose Jones, W. T. Fulford, unidentified, Clyde Fulford, and W. A. Adams. All of the Fulfords are descendants of the six sons and two daughters of David and Mary Efferce Fulford of Carteret County, North Carolina.

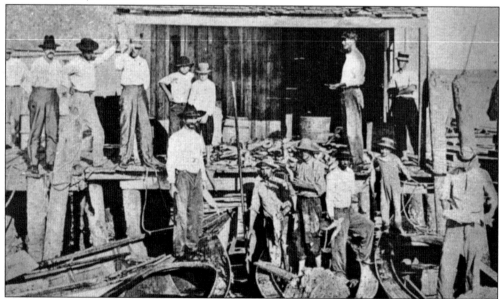

Fishermen unload their catch at the Cortez docks while other men watch. A young boy dressed in overalls stands at the prow of a nearby boat watching as the men show off their catch. It was not unusual for seine netters to haul in several tons of mullet in one day, particularly during the spawning season in the fall or during unusual stormy weather that drove large schools of fish out into the Gulf of Mexico.

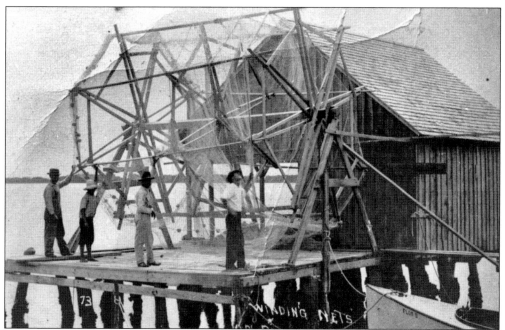

Cortez fishermen wind their nets on a drying reel to avoid mildew and rot. The reels allowed the circulation of air and saved dock space. The men are, from left to right, Burns Taylor, Julian and John Taylor, and Jess Williams. Julian married Bessie Carter and organized the volunteer fire department. John homesteaded on Longboat Key, and his wife, Nola Victoria, was a nurse recruited by Burns to care for his wife, Annie, who was ill.

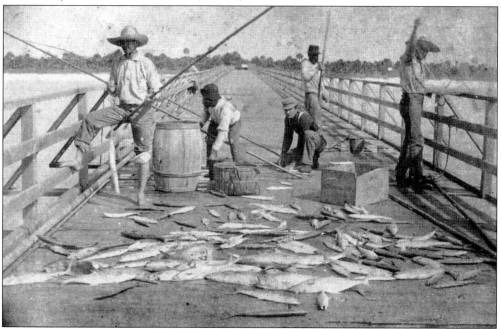

The Cortez bridge, which connected the mainland to Anna Maria Island, was used not only for cars, but also as a favorite fishing spot. The bridge was begun in the summer of 1921 and was completed the following year at a cost of $68,000.

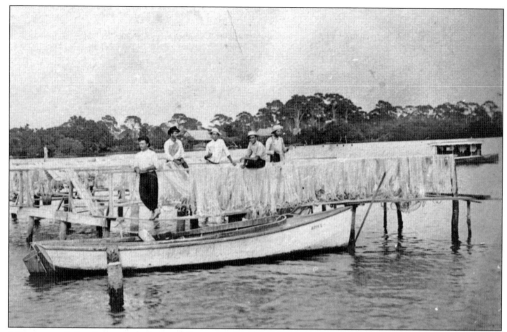

Men rest while their nets dry on the racks made for that purpose. In the background are two Cortez homes built close to the water. Pilings can also be seen in the distance, remnants of burned docks. Commercial fishing was very competitive and it was difficult for newcomers to compete with established fishermen.

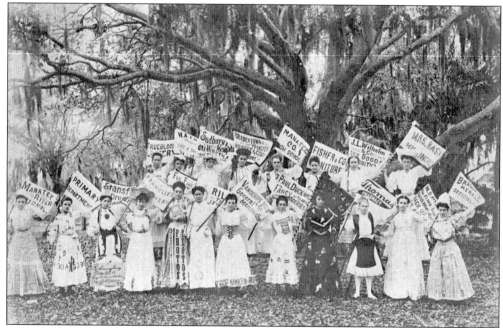

In this c. 1900 photograph, representatives from all types of establishments meet in Fuller Park to advertise their products. Girls display signs for the Thomas Pharmacy, Vanderipe Brothers General Merchandise, Fischer Company Furniture, Stansfield and Company Drug Store, J. L. Wilhelm, and numerous other businesses.

J. M. Stansfield owned the drug store in the building that housed the Warren Opera House in Bradenton. Not only did he sell drugs and medicines, but he also sold ink tablets, toilet soaps, school supplies, seeds, dyes, perfumes, cigars, soda, ice cream, and candy. In 1905, Stansfield added millinery and served as the sales officer for plays and events at the opera house. He also provided medicine for prisoners at the local county jail. This photograph was taken in 1900.

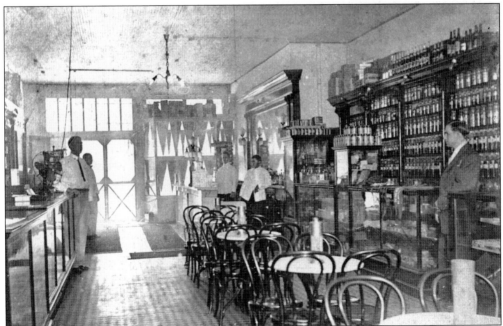

The Scroggins Family Drug Store, often called the Bradenton Drug Company, was located at 411 Main Street. This c. 1920 photograph shows the store, which became one of the favorite meeting spots to socialize during the Roaring Twenties. Medicines were available, but sodas and ice cream were the most popular items sold.

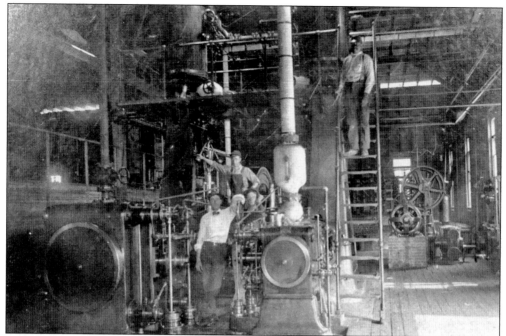

Three men work at the Palmetto Ice and Power Company, which filed for incorporation on November 16, 1901. The plant produced ice, but it was also designed to provide electricity. The Manatee Ice and Cold Storage Company took over the Palmetto operation in 1901. The Tampa Ice Company built a plant in 1909, and in 1918, the Atlantic Ice Company bought it out.

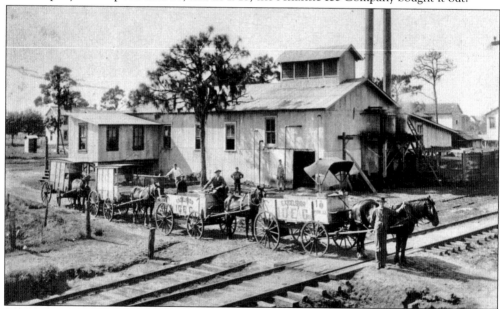

Several horse-drawn wagons stand waiting in front of the Exselsior Ice Company at 115 Beach Street in Bradenton. This 1917 photograph shows how ice was distributed to homes in the neighboring community. Housewives would generally place a sign outside the front door that was clearly marked to tell the iceman how much ice should be delivered. He would then carry the ice with tongs and place it in the waiting icebox.

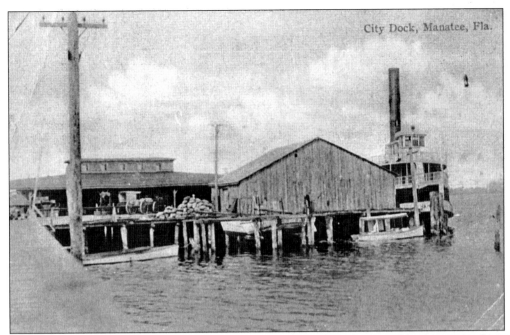

A steamboat has pulled in at the dock in the Village of Manatee. A horse-and-buggy waits in front of the King Wiggins packinghouse, which is at the rear with the high, raised windows. Steamboats made regular visits to deliver merchandise to King's drugstore, returning with loads of citrus or vegetables to ports such as Tampa or Mobile, Alabama. Merchandise for other businesses was also delivered at many of the wharves up and down the Manatee River.

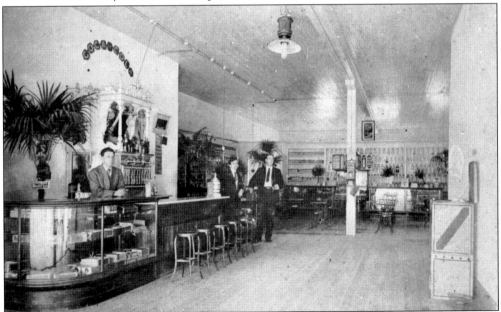

This interior of the Red Cross Pharmacy in Palmetto is rather typical of other drugstores with its cigar counter and soda fountain offering Coca-Cola. However, this one appears to be rather sparsely furnished. Most drug stores had added treats like ice cream and other delicacies and chairs and tables for sitting. The men in the photograph are unidentified.

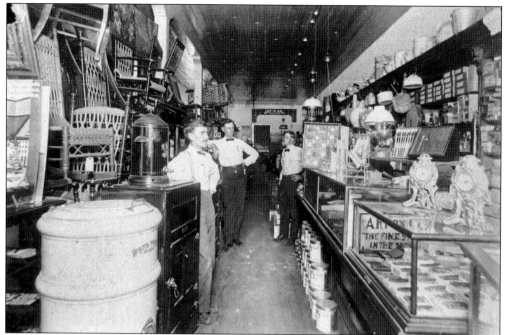

This hardware store in Palmetto was owned by J. B. Owen and J. W. Nettles. It sold chairs, lamps, cooking utensils, and almost anything needed in the home. Gallons of paint are lined up on the floor next to the glass cases that were filled with items like pocketknives and tools. The men in the photograph are unidentified.

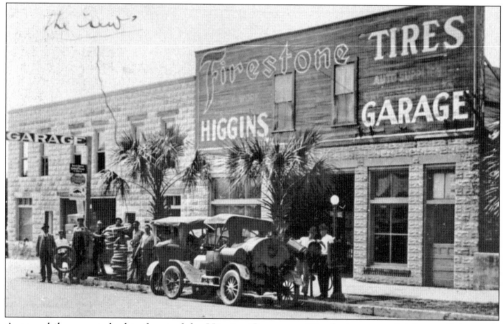

Automobiles are parked in front of the Higgins Garage on Tenth Avenue, which was Palmetto's main street. The building was once the Mitchell Car Sales Building, which was purchased from the Parrish family. Higgins added the brick building next door, which sold Firestone Tires and other automobile products.

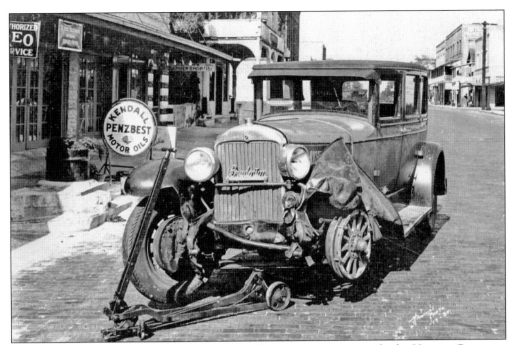

In this *c.* 1929 photograph, a wrecked automobile waits for repair outside the Higgins Garage in Palmetto. There is a sign that reads "Authorized REO Service" and another that advertises Kendall Penzbest Motor Oils. A tire has been removed with the use of a vintage jack. A barbershop is next door, marked with two red-and-white-striped poles.

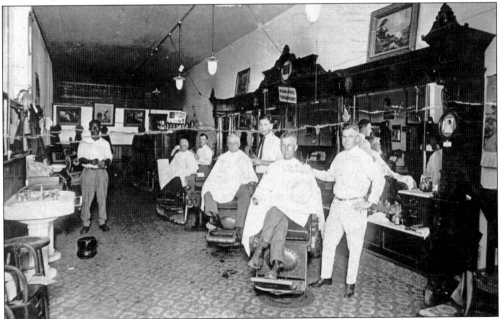

This barbershop in Bradenton appears to be busy with customers filling the three barber chairs. Many of the shops had only one chair, and customers usually had to wait for their turn. This larger barbershop was owned by Cecil S. Lippard of Palmetto and Willfred F. Sullivan of Bradenton. This photograph was taken *c.* 1923.

Workers sit outside the Ward-Graack Potter business in Bradenton on Park Street. Pictured from left to right are (first row) Henry P. Graack and Carolyn Phillips; (second row) unidentified, Mrs. Ward, and Denise Shields. Clay used by the business was dug near the Manatee River at Riverview Boulevard and Twenty-seventh Street.

In this c. 1918 photograph, the Gulf Oil Corporation's horse-drawn delivery wagon sits on Corwin Dock. The Gulf Oil Corporation also purchased land from J. A. Howze west of his wharf in Palmetto to construct a dock for barges to unload oil to their adjacent storage tanks. This oil company was the largest one to operate in Manatee County.

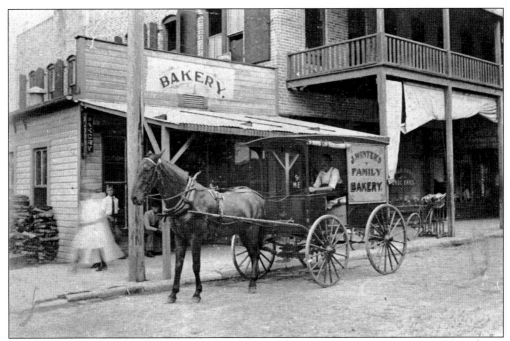

J. Winter's bakery sits on Main Street in Bradenton next to a newer brick grocery store. Winter's place was a small wooden building, but he used a horse and wagon to make deliveries throughout Bradenton. Stacks of wood used for heating the ovens are next to the building.

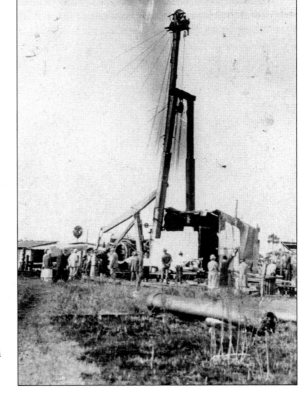

Three attempts were made to find oil in Palmetto between 1924 and 1928. George E. Wallace was president of the Tri-County Oil Company, which made the attempts. The drilling tools broke off when they reached a depth of 1,300 to 1,400 feet, and the well was abandoned. The photograph shows a two-post drilling derrick. A four-post derrick later reached a depth of 2,600 feet but, unfortunately, only found an ample supply of water.

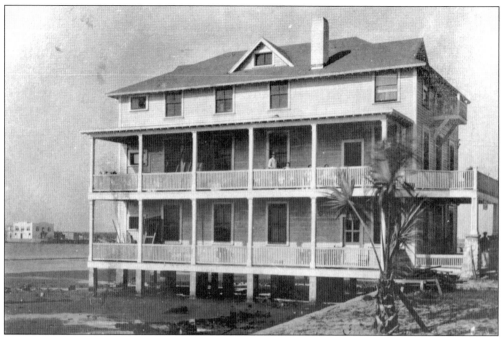

H. Hinsman built this apartment building in 1897 on the waterfront next to the dock in Palmetto. A seawall was built to keep out the water, but it obviously did not work since the ground under the building was soaking wet even at low tide. It was built by the Palmetto Wharf Company, which consisted of S. S. Lamb, J. A. Howze, and J. A. Lamb. The building burned, and the land later became the site for the Regatta Point Marina.

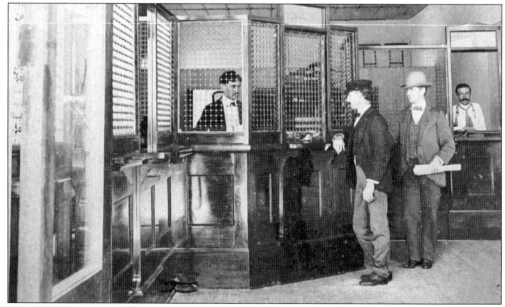

The First National Bank of Bradenton was located in the lobby of the Warren Opera House building. Customers are waiting for service at the cashier's window. John F. Vanderipe Sr. was president of both the First National Bank and the United Abstract and Title Insurance Company. He was also the treasurer of the Florida Grapefruit Canning Company.

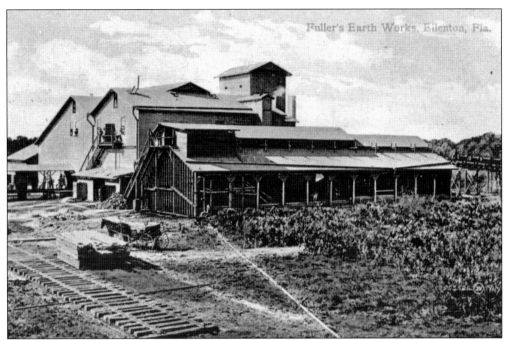

The Atlantic Refining Company's fuller's-earth-mining works at Ellenton was the largest industrial operation south of Tampa. It was located at the eastern end of Ellenton near Rocky Bluff and the Manatee River. The operation was opened in 1903 and employed 150 workers. The topsoil was removed by steam shovels and piled high, leaving pits resembling small lakes. Pine and oak woods were hauled in by mule-and-wagon to stoke the large furnaces. The clay-like substance was placed in large revolving iron drums, and the clay was dried in a heated stack. It was then bagged and sifted into four different grades. The coarse grade was preferred by Texas oil refineries. The plant burned twice. It first burned and was rebuilt in 1910; it burned again in 1922 and ultimately closed.

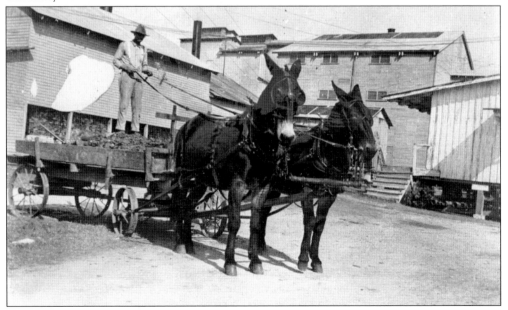

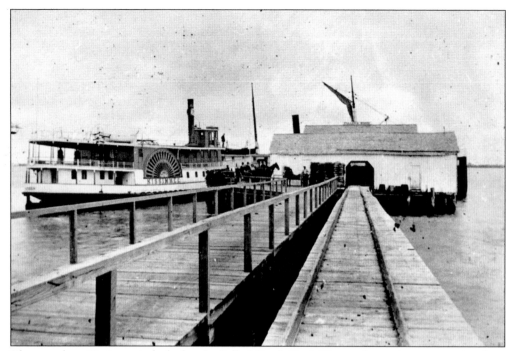

The steamboat *Kissimmee* is docked at the Fuller's Earth Dock. The tracks can be seen running from the plant and through the opening of the loading platform. There were several steamboats that hauled the fuller's earth to waiting ports, particularly in the Gulf of Mexico. There the material was transferred to trains headed for Texas, where most of the clay was used for refining oil.

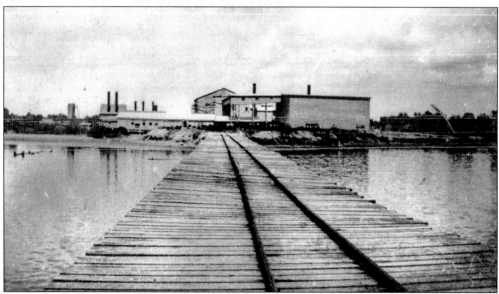

This *c.* 1915 photograph is a view of the Atlantic Refining Company taken from the dock on the Manatee River. It offers a rare glimpse of the fuller's earth processing plant. Today one can see the remnants of pilings from the dock while driving over the bridge at the Ellenton exit on I-75. Beyond these buildings are the pits, which currently serve as lakes for waterfront living.

Four

CHURCHES AND SCHOOLS

Most of the early settlers who moved to the south shore of the Manatee River in 1842 were religious people who also valued the importance of education. Among the early arrivals to the area were the Reverend Edmund Lee and his wife, Electra, who came in 1844 and boarded in the Gateses' home in the Village of Manatee. They held services in the dinning room at the Gateses' house. Reverend Lee recovered from his illness of consumption and was soon rowing his boat across the river to preach to the slaves at the Gamble plantation. The Lees bought property nearby and built a house made of tabby with layered tar and burlap to keep the cold out. The upstairs of an adjoining room was used as a schoolroom for pupils. Electra charged each student $5 per term. This was the beginning of the Manatee Academy, the first private school in Manatee County.

Union churches, which served several denominations, were built in many communities, and the local schools were often housed in the same buildings, but it wasn't long before Methodists, Presbyterians, Baptists, Episcopalians, and other denominations quickly established themselves independently and were soon building new churches almost side-by-side. Schools were later built separately from churches so that the needs of both religion and education could be met.

This chapter highlights many of Manatee County's schools and churches. Through vintage photographs, it represents a sampling of the county's insatiable thirst for education and spiritual values.

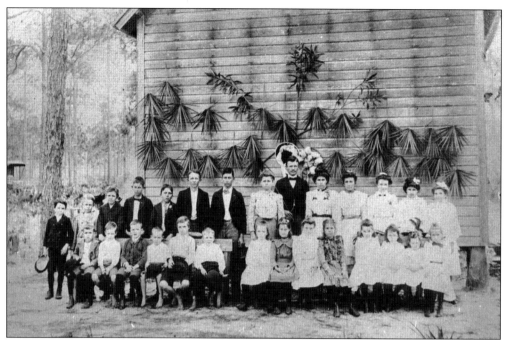

The Braden River School students pictured here are, from left to right, (first row) three unidentified, Henry Johnson (later a member of the New York Yankees), and 10 unidentified; (second row) Gib Johnson, unidentified, Gordon Johnson, Lucian Kennedy, Luke Kennedy, Bud Pope, Tom Kennedy, Inez Johnson, H. M. Freeze (the teacher), unidentified, Lula Kennedy, Dora Kennedy, Ida Kennedy, and Leticia Kennedy.

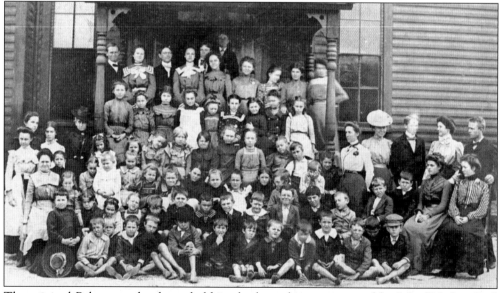

The original Palmetto school was held in the log cabin once owned by Julia "Madam Joe" Atzeroth. The school employed a private tutor hired by S. S. Lamb for his and his neighbors' children. This much larger second school opened later on the corner of Fourth Street and Ninth Avenue. Frankie A. McKay was the principal of the new school, which had 60 students. McKay later married James Howze, a widower who lost his first wife to yellow fever.

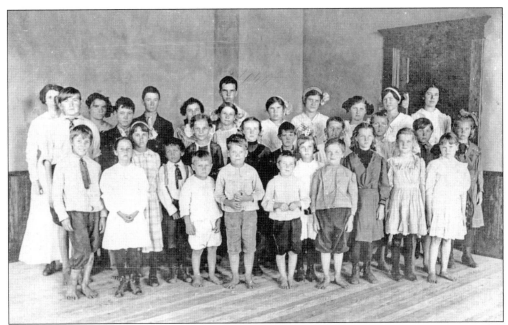

Students at the Palma Sola School pose with their teachers, Orrie Pratt (top left) and Margaret Dole (top right). Pictured from left to right are (first row) unidentified, Freda Maxon, Julia and Austin Switzer, Frank Felts, Furman Smith, Robert and Harry Gilliat, Myrtle Roers, Thelma Smith, Reuben Stowe, Wilbur Sikes, Clyde Phelps, Marion Warner, Howard Pettigrew, Ellen Gilliat and Nettie Rogers; (second row) unidentified; (third row) Alonzo Stowe, Ruby Sikes, Ross and Carl Felts, Lena Rogers, Carlos Earle, Ethel Stowe, Agnes Rogers, Ella Simpson, and Cara Davis.

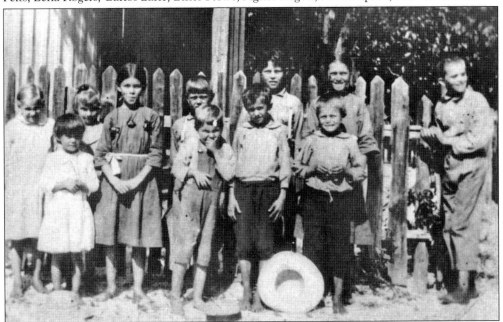

Students at the Albritton School are pictured here from left to right: (first row) Rosie Keen, Mary Keen, Horace Smith, Owen Keen, and Alex Chancey; (second row) Ella Peacock, Agnes Smith, Warren Chancey, Alfred Keen, Lillie Keen, and Miller Keen (far right).

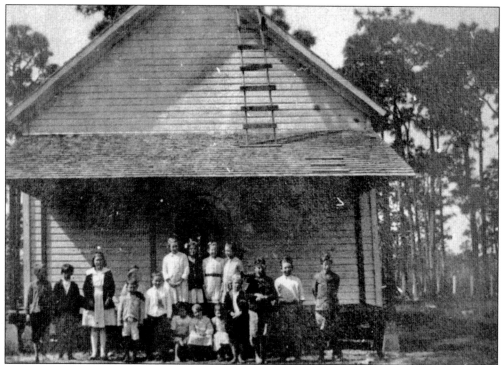

This early school was near Rye, about 29 miles from the beginning of the Manatee River. The teacher was Mae McLeod. It was one among several schools opened in the 1880s. Called strawberry schools, the classes ran from April through December so that children could help in the harvest. Several of the schools were consolidated in 1894 into the Duette School, the one-room school that survived over the years and still remains today.

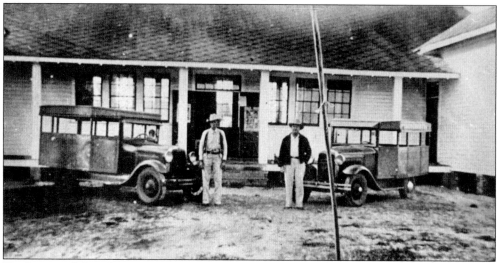

Two buses and their drivers wait outside the Duette School in 1932. Several schools consolidated when transportation became available, but the school still had only one teacher. That same school continues as a one-teacher institution into the 21st century in spite of much debate among county educators as to the validity of keeping it open. Most of the students rank high with their grades.

Leslie Lee Hine, superintendent of schools in Manatee County from 1898 to 1912, poses with his bicycle on March 21, 1898. Hine was the son of Elizabeth Siddall Hine and Miller Jacob Hine. The family moved from Texas to the community of Rye in 1882. They traveled by boat from Texas to Cedar Key with their five children: James Peter, Mary Leavenworth, Leslie Lee, Charles Miller, and Ruth.

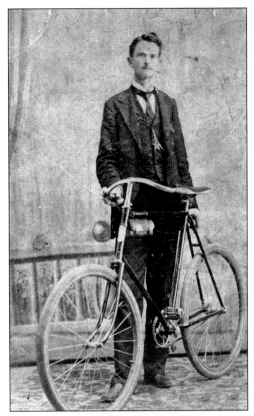

Students gather on the steps of the Palma Sola School. The first school mentioned in Palma Sola was in 1888, and the teacher's salary was $22.50 per month. A newspaper article states that a Mr. Curry was the teacher in 1899, followed by Alice Warner. The school got new desks in 1900. Minnie Glazier from Oneco was a teacher in 1902, and Mrs. S. W. Enlow taught in 1906, followed by Gertrude Place in 1908.

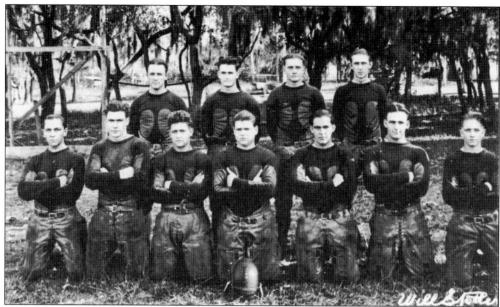

In this *c.* 1910 photograph, members of the Palmetto High School football team pose under the shade of oak trees. Pictured from left to right are (first row) Fred Snyder, Justice Bradley, Harold Robinson, J. P. Harllee, Charles Robinson, Austin Brown, and Melvin Skene; (second row) Massey Edwards, Lee Hunt, Marion Skene, and Alpho Smith.

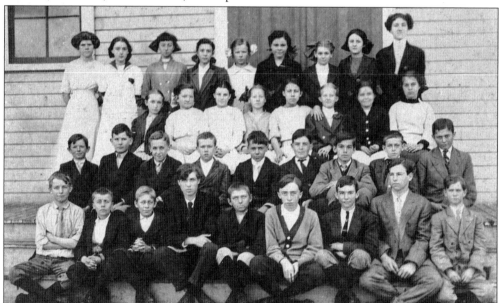

Students pose at the old wooden Intermediate-High School in Bradenton *c.* 1911. Pictured from left to right are (first row) Howard Lathrop, Cairo Trimble, Lawrence Kretschmar, two unidentified, Dallas Simmons, and three unidentified; (second row) unidentified, Mitchell Alderman, Miner Herrin, unidentified, Milton Burnett, unidentified, Donald Beck, Harold Stansfield, and unidentified; (third row) Gracie Walden, unidentified, Helen Christopher, unidentified, Edith Breeze, unidentified, Gladys Osborn, and Lucy Edmundson; (fourth row) nine unidentified.

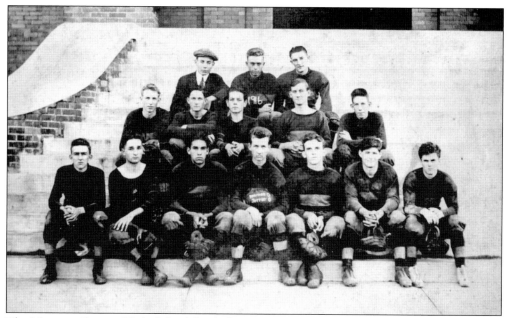

The Manatee County High School football team poses on the steps of the brick school built in 1912. Pictured from left to right are (first row) Charles Phillips, Dewey Dye, Donald Beck, Alden Pearson, Haymond Taylor, Arthur Tyler, and A. K. "Klein" Whitaker; (second row) Howard Lathrop, Lawrence Fortson, ? Colson, Leon Amlong, and Ralph Gates; (third row) coach Julian C. Howard, Kehr Knight, and Taylor Scott.

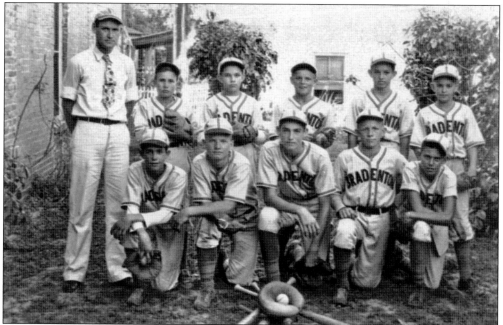

Bradenton High School's baseball team were county champions in 1939. Pictured in no particular order are Rowe Meade, Elwood Lovestead, John Scott, Leon Lockart, George DeLesline, C. W. Weldon, Jimmie Turner, Peter King, H. M. Willis, and coach James Hightower. One person remains unidentified.

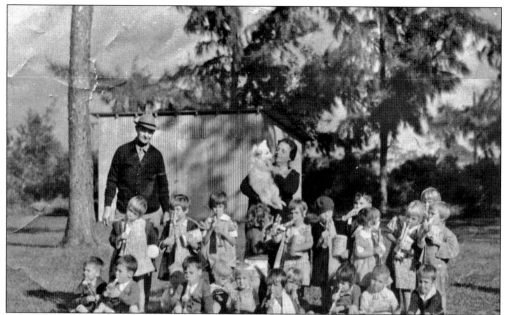

Dr. and Mrs. Barnes visit the Cortez School children with new horns. Pictured from left to right are (first row) Richard Culbreath, Lloyd Capo, Joe McDonald, Floyd Capo, Judy McDonald, Shirley Jones, Wanda Jones, Betty Craig, Helen McDonald, John McDonald, and Ernest Craig; (second row) Edith Capo, Nita Mae Lewis, Patty Taylor, unidentified, Nettie Jane McDonald, Morris Guthrie, Emily Taylor, Martha Lewis, Carolyn Pringle and Annette Evitt; (third row) Dr. and Mrs. Barnes and an unidentified dog.

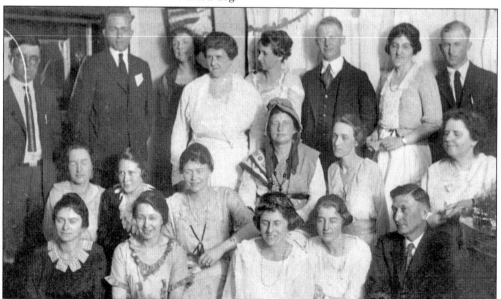

Members of the Manatee County High School's faculty are pictured here c. 1921. From left to right are (first row) unidentified, Corrie Smith, Mrs. Fred Christopher, Julie Hubbel, and A. B. Murphy; (second row) Maida Young, Mrs. Kehr Knight, unidentified, Dr. Mary Green, Monnie Neil Jones, and Mrs. A. B. Murphy; (third row) unidentified, Kehr Knight, unidentified, T. D. Hayes, Margaret Boutelle, and three unidentified.

Pupils line up outside the wooden Bradenton Elementary School in 1910. The first school built in the county was the Manatee Academy. Education was always highly respected, since most of the early pioneers in the Village of Manatee were well educated. Flora McLeod was a young teacher hired by the McNeils to teach their children and the Gateses' children at the Gamble Mansion after the war. The older daughter, Katie Gates, was at the University of Florida.

This c. 1923 photograph shows the tremendous increase in the school population during the years after the above image was taken. Bradenton's Primary School students line up on the front porch of the school. The new Biltmore School opened in 1925 to meet the demands of a rapidly increasing population.

Unidentified children and their teachers pose in front of the second Oneco School, which replaced the old wooden building that served both as a church and school. The first building was erected in the 1870s, but the new school was much more durable because it was constructed of concrete blocks. Grades first through eighth attended the school.

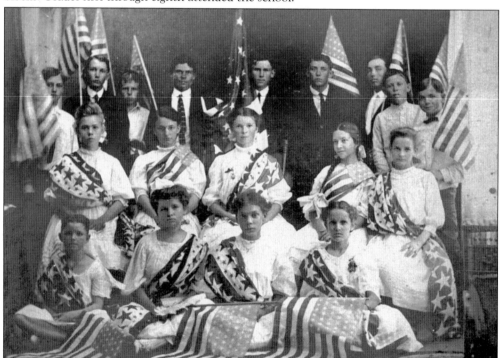

The Manatee County High School was located on Manatee Avenue at Chestnut Street. In this 1910 photograph, high school students pose with American flags. Pictured from left to right are (first row) Addie Lou Knight, Ruby Mitchell, Beth Harris, and Elizabeth Rood; (second row) Frankie Baxter, Irma Lathrop, Marie Shirley, Mable Harris, and Oma McLeod; (third row) nine unidentified.

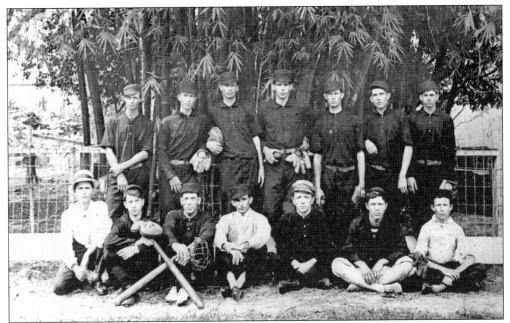

This *c.* 1914 photograph of the Palmetto High School baseball team shows, from left to right, (first row) unidentified, Ottway Walter, Brabham Duncan, Victor Nettles, Dr. Clark, Jamie Howze, and Percy Smith; (second row) George Owens, Jim Armstrong, Ed Owens, Harry Culbreath, Ledbettes Morgan, Millard McDougal, and Francis Owens.

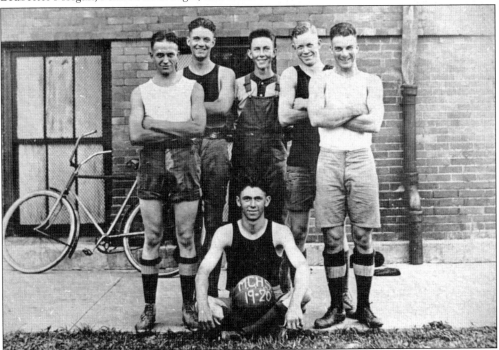

The Manatee County High School's 1920 basketball team included the following, from left to right, (seated) team captain Garnet Puett; (standing) John Jenning, P. T. Dix Arnold, team manager Lorris Gates, Milton H. Wyatt, and Gilbert Johnson.

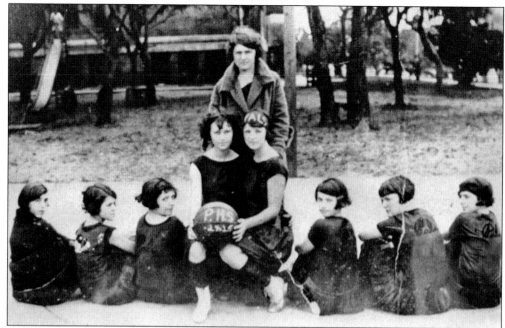

The 1924–1925 Palmetto High School girls' basketball team posed for this photograph on the school grounds with their unidentified coach (standing). Pictured from left to right are unidentified, Irene Beazley, Carmen Whisenant, two unidentified, Emma Tyler of Ellenton, and two unidentified.

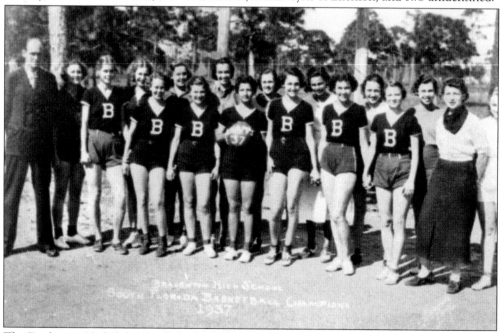

The Bradenton High School girl's basketball team won the South Florida championship in 1937. Pictured from left to right are (first row) coach Jimmy Hightower, Ruth Hampton, Leuna Perry, Marion Ridgdill, Edith Kennedy, Opal Jamison, Shirley Griffin, Clara Belle Balis, Georgie Gates, and manager Leonora Armstrong; (second row) Jim Murphy, unidentified, Mary Lou Longino, Francis Alderman, Jessie Beth Longino, Morrell Albritton, Doris Snow, and Elanor Hill.

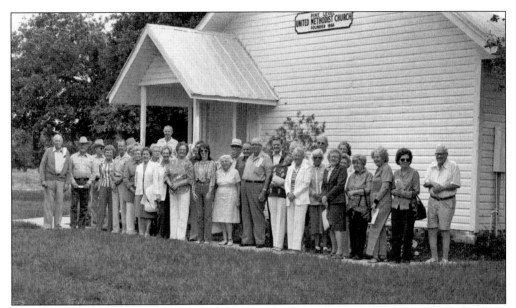

The members of the Manatee County Historical Society pose at the Pine Level Methodist Church, which was built in 1868. Pine Level was the county seat and was a thriving town with a jail, a courthouse, and approximately 17 saloons. Alice Myers, one of the county's most active members, is fifth from the right.

The Christ Episcopal Church at Willemsenburg, pictured here c. 1890, was built in 1887 on a lot donated by Johan Willemsen, who was in competition with John Fogarty. The church was built near the Manatee River in a small settlement that is now Twenty-sixth Street. A bell that was cast in France and weighed 889 pounds was donated to the church by George Murray Barney. Meanwhile the yellow fever epidemic stopped work on the Methodist Episcopal church in the Village of Manatee.

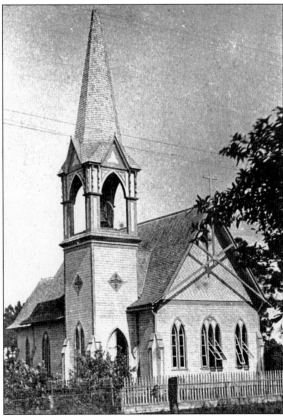

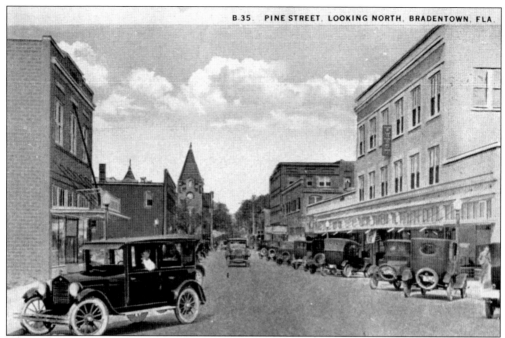

The steeple of the First Baptist Church, located left of center, rises above Manatee Avenue from this view of Pine Street (later called Thirteenth Street West). The original building was made of wood. The Presbyterian church was built next door, and the two churches currently form an anchor to Manatee Avenue on the western end of downtown Bradenton. Note the busy traffic.

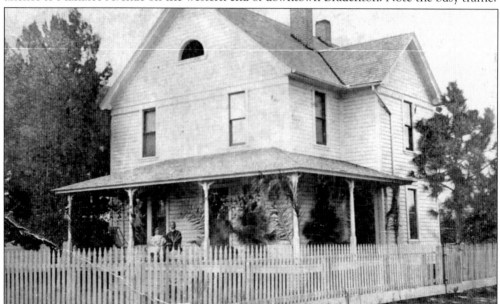

The First Presbyterian Church manse at the corner of present-day Fourteenth Street West and Manatee Avenue was built in 1901. It was later used as a school of music led by Olive Nickell and as rooms for Sunday School classes. The house was relocated to Seventh Street West to make room for the new church in the late 1940s. Seated on the porch are the Reverend J. L. Lander and Gertrude Fuller, the wife of Elon Rood.

One of the first churches built in Manatee County was the Methodist church in the Village of Manatee. It was built in 1887 and was recently moved and renovated for exhibit at the Manatee Village Historical Park. The park, located at 604 Fifteenth Street East, is open to visitors.

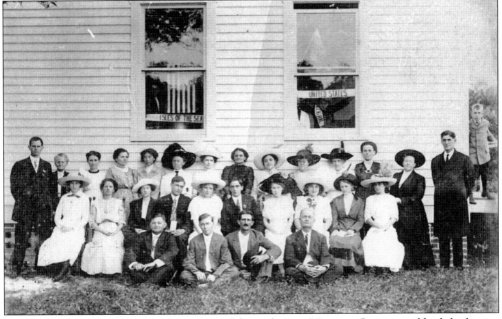

The Manatee Methodist Church was one of the earliest in Manatee County and had the largest number of members during the years soon after the arrival of the pioneers in the 1840s. Two members of the Gates family became ministers; Rev. E. F. Gates retired from the ministry in 1883, and J. E. Gates later became a minister. This c. 1910 photograph shows members of one of the adult Sunday school classes.

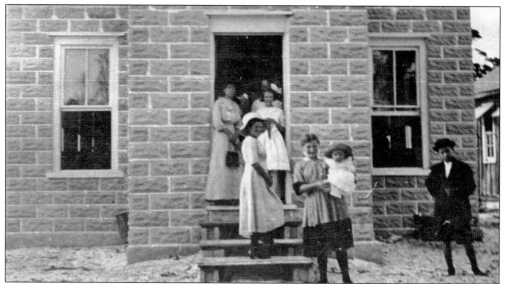

A group of girls poses on the steps of the Palm Sola Community Church in 1912. A. N. Pillsbury donated land east of his property in 1910 for the church, and it was built by John B. Rogers. Rogers and his wife, Sara Lucinda, had six children: Douglas, Carlisle, Agnes, Lena, Nettie, and Myrtle. The church replaced the old wooden building, which had also served as the school.

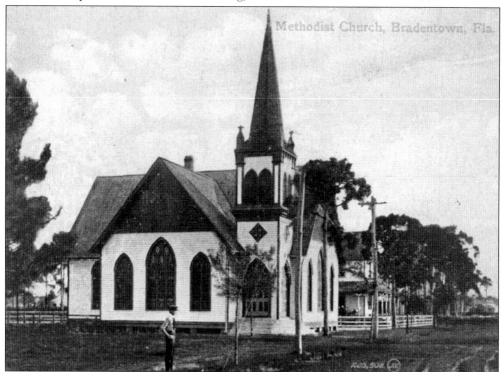

The old Bradentown Methodist Church stands among pines on an unpaved road with wagon ruts, much unlike its setting today, which is downtown in the heart of the busy city. Most of the early residents in the Villae of Manatee were members of the Manatee Methodist Church, but the population shifted toward the west, and businesses quickly surrounded all of the rural settings.

The Baptist men's Sunday school class in Palmetto are pictured from left to right: (first row) secretary ? Wellington, unidentified, J. C. Smith, M. Edwards, E. H. Mason, D. Jones, J. P. Harllee, E. Robinson, L. McLeod, C. Wharton, and Reverend Benson; (second row) O. W. McClure, unidentified, J. McBrayer, R. Swain, ? Selman, ? Thomas, J. Bruce, Gordon C., ? Spivy, K. Hiday, and T. Jenner; (third row) unidentified, P. Smith, J. Robinson, H. Weeks, ? Beaves, L. Parker, T. Paul, N. Theriot, T. Paul, C. Everett, and L. Parker.

Services at St. Joseph's Catholic Church of Bradenton were first held in this old wooden building on Twelfth Avenue before the congregation moved to the large property on Twenty-sixth Street West. This site later became home to the congregation of Sacred Hearth Catholic Church. This photograph was taken in December 1964.

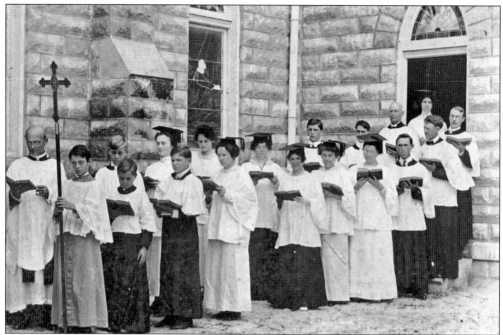

In this 1910 photograph, the Christ Episcopal Church Choir in Bradenton is ready for services. The church was located on the corner of Fourteenth Street West and Fourth Avenue but moved later to Forty-third Street West on Manatee Avenue. The members, wearing robes, are likely waiting to begin their processional down the aisle to begin the worship service inside the sanctuary.

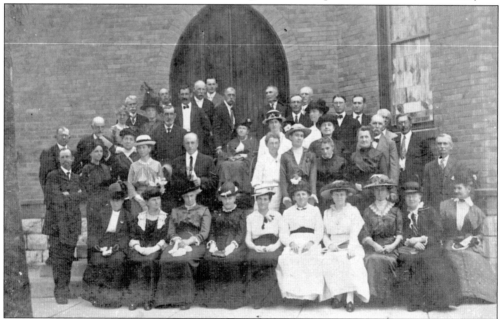

In this 1915 photograph, members of the First Presbyterian Church in Bradenton pose in front of their church at 1402 Manatee Avenue West. One elderly woman sits in her wheelchair in the center. A few of the ladies are posed without hats, an unusual sight for the times. The fellow on the far left with his arms crossed appears to be bored.

Five

THINGS TO SEE AND PLACES TO BE

There was never a lack of things to do for residents of Manatee County. Fishing from the banks of freshwater canals, lakes, and streams was a common pastime, as was fishing with fiddler crabs under the trestles that crossed the brackish water of the Manatee River. Family ventures into the saltwater bayous reaped scallops, clams, and blue crabs. Mackerel runs enticed multitudes to line the piers, and cast nets could commonly be seen hanging out to dry when mullet were plentiful. Knowing the tides was important.

Guavas, blackberries, and sea grapes were harvested for jellies and jams, and candied citrus peels provided goodies for the holidays. Wives lined their shelves with jars of vegetables gathered during the growing seasons, and children made canoes from sheets of tin nailed to the ends of tomato crates, patched together with melted tar. There was always plenty to do for the local folks.

Nor was there ever a lack of recreational activities for tourists. Steamboats chugged their way up and down the Manatee River, bringing passengers by the boatloads from places such as Tampa and St. Petersburg. Anna Maria Island became one of the most popular destinations for tourists during the winter months and became alive with local residents during the hot months of summer. The advent of railway travel advanced tourism, as did the flow of travel by automobiles during the winter months, when tourists flooded the area in search of warm sunshine and easy living. Ferryboats traversed Tampa Bay laden with automobiles. Hunting and fishing expeditions were offered to tourists, and excursions featured the sightings of deer, turkey, bears, and alligators.

The exotic Manatee River, the white sandy beaches, and the warm waters of the Gulf of Mexico offered a pristine setting unlike any other in Florida, and it was soon known that Manatee County was a fun place to live or visit.

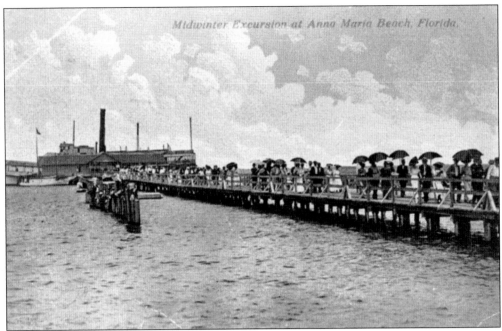

One of the most popular destinations in Manatee County was Anna Maria Island. Excursions were popular, and several steamboats made regular stops at the pier. In this 1910 image, a stream of passengers is seen departing from the boat and walking down the pier with umbrellas open. Passengers arrived daily from Tampa, St. Petersburg, Sarasota, and other local wharves, including Palmetto, Ellenton, Manatee, Bradenton, and Palma Sola.

A group of boys gather on the diving platform at Anna Maria Island in 1925. The island was a favorite place for house parties during the summer months for Florida residents. These young men were house guests of J. Romeo and Pearl Woods of Ellenton at their large beach home near the point on the bay side of the island.

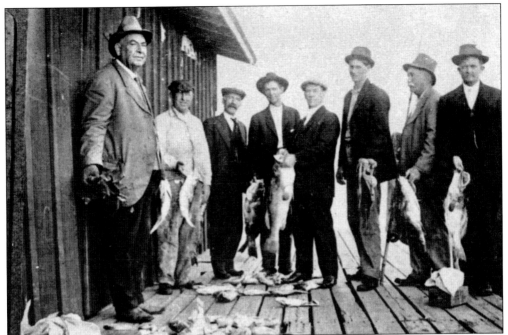

Successful fishermen pose with their catch on the Palmetto Pier, which also housed a restaurant. Among the men are Johnny Owens, a Mr. Willis, and Virgil Duncan. The other men are unidentified. Groupers, snappers, mackerel, and sheepshead appear to be part of the catch. Mullet were plentiful and were commonly caught with cast nets up and down the Manatee River.

In this January 5, 1901, photograph, a group of unidentified people enjoy a picnic on one of the four docks in Ellenton. This was a common way of socializing before catching one of the steamboats for an excursion on the Manatee River. Note how well the people are dressed and the warm clothing because it is the middle of Florida's winter. Summer outings to Anna Maria Island ended before dark to avoid swarms of mosquitoes.

113

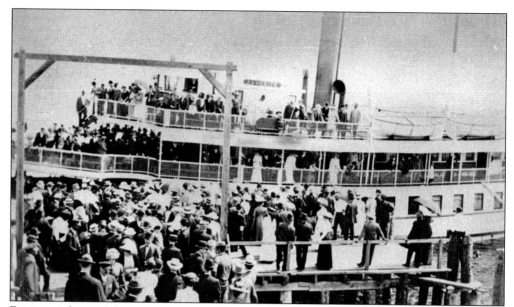

Excursions by steamboat were among the favorite recreational activities of locals and tourists alike. In this 1915 photograph, the steamer *Favorite* is loaded down with passengers waiting to take an excursion trip while friends and family bid them good-bye from the dock. The *Favorite* was one of several boats in the Favorite Steamship Line.

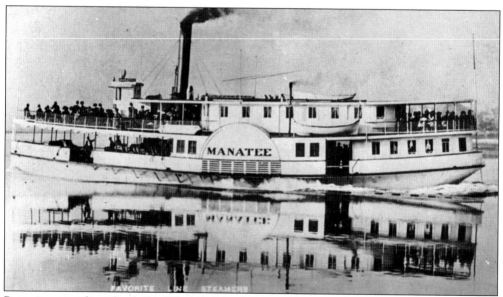

Passengers stand on the deck of the side-wheeler steamboat *Manatee* of the Favorite Steamship Line. In 1910, her schedule began at 5:45 a.m. in Terra Ceia, then on to St. Petersburg at 8:00 a.m., and then she arrived in Tampa at 10:00 a.m. The *Manatee* left Tampa at 5:00 p.m. and arrived at Terra Ceia via St. Petersburg at 9:00 p.m. Bradenton, Palmetto, Ellenton, Sarasota, and Anna Maria Island were added to the schedule in 1911.

A group of passengers from the steamboat *Margaret* views a shark on one of the docks. Steamboats were a common sight on the Manatee River during the 1890s. Sharks were always a curiosity for tourists. Swordfish were also caught regularly in the river. One caught on the Palmetto Dock exceeded 13 feet.

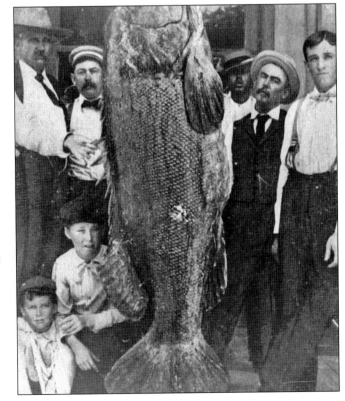

This 262-pound jewfish was caught in the Manatee River c. 1910. The man in the white cowboy hat is Thomas R. Easterling, sheriff of Manatee County. The boy and the other men are unidentified. It was not unusual for large fish to be caught in the river. C. W. Bratton once caught a 460-pound jewfish off Corwin's dock.

In this October 1916 photograph, a Halloween party is held in Palmetto that includes young people from neighboring communities. An unidentified lady sits at the piano, so singing must be part of the activities. At the far left on the floor are Ernest Parrish and Frances Hebble, who were married soon after this photograph was taken.

Eugene Turner supervises his children. Pictured from left to right are Pete, in the arms of the unidentified nursemaid, Raymon, Bob, Ralph, and Eugene Turner. This picture was taken at the corner of Twelfth Street West and Fourth Avenue West where the Hardin building later stood. The Winston Bakery and the Gaar House are in the background.

In this 1900 photograph, four local men proudly display their kill for the day. The hunters are, from left to right, John F. Vanderipe Sr., William H. Vanderipe, John Lane, and Henry Curry. Waterfowl were plentiful at the time. Quail, turkey, and deer were also abundant, luring tourists from the North to go on hunting safaris with guides who advertised in Northern newspapers.

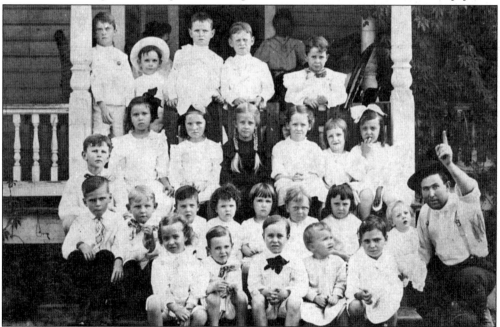

Many local children enjoyed Bob Turner's birthday party. Pictured from left to right are (first row) C. F. Owens, Bob Turner, Francis Rickelman, Burton Osborne, and Joe Scholze; (second row) Turner Clark, Clarence and Ralph Turner, Marian Curry, Eleanor Thomas, Rusie Wilheim, Pauline Roesch, Eugene Turner, and Robert Turner; (third row) Garland Turner, Lucy Edmundson, Emile Wilhelm, Gladys Osborne, Blanche Harvey, Lois Curry, and Margaret Owens; (fourth row) Klein Whitaker, Pat Stausfield, Byron and Herman Turner, and Herman Burnett.

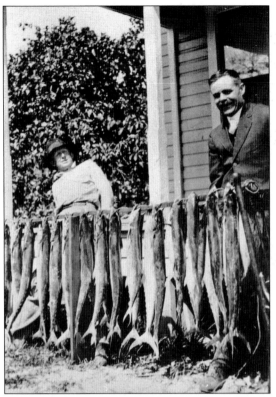

In this 1910 photograph, attorneys Walter H. Tucker (left) and Jonathan B. Singletary show off their catch by hanging them on a porch railing at Tucker's home. The catch appears to be kingfish. Tucker later became a judge in Manatee County, and Singletary became one of the most popular attorneys in the county.

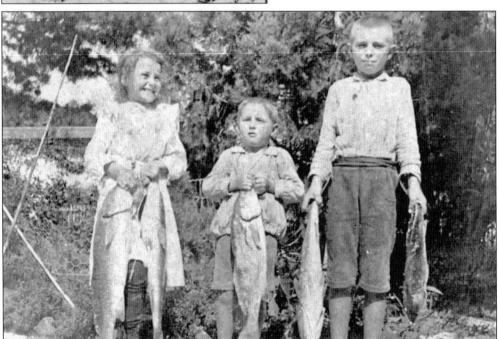

The three Roesch children pose with their catch, which includes a large redfish. Pictured from left to right are Mildred Marguerita "Toodle" Roesch, Robert Herman "Nig" Roesch Jr., and Otto Emmit "Monk" Roesch Sr. Robert became a pharmacist at the Braidentown Drug Company.

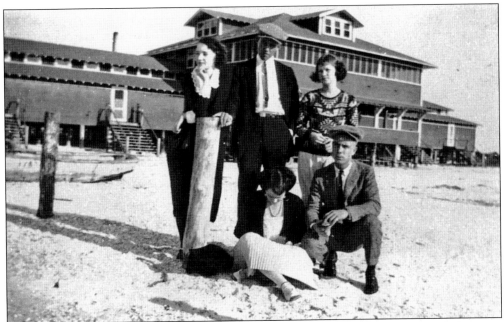

Five young adults stand in front of the pavilion bathhouse at Bradenton Beach, which was commonly referred to as Cortez Beach. Mules and wagons hauled lumber over the partially completed bridge from Cortez to the island on Bridge Street in 1922 when this building was begun. The building cost $30,000 to build but burned down in 1923. It was rebuilt for $40,000 but burned again in 1929.

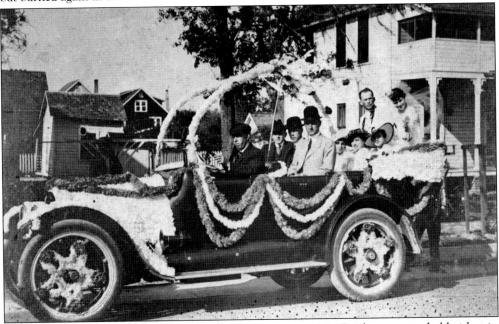

This Fourth of July parade, moving down Manatee Avenue in Bradenton, was held either in 1915 or 1916. The decorated car possibly belonged to the Curry family. Pictured from left to right are Pud Stanford, Warren Curry, D. B. Sutton, Ed Curry, Phyllis Carnes, Iva Rowlett, Carolyn Phillips, Chuck Rushston, and Annie Lee Knight.

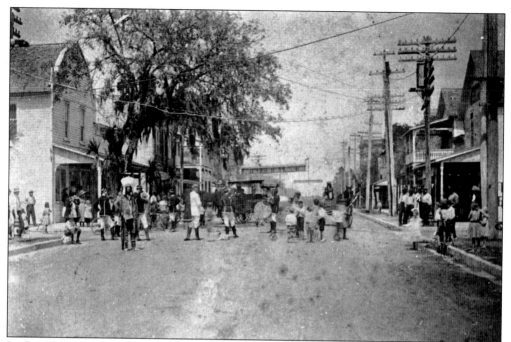

In this 1917 photograph, people gather underneath a large oak tree to watch a band on Palmetto's Main Street. Horses and wagons gather, but some have arrived on bicycles. On the left are people standing outside the building, while others stand in the shade of the store's porch. One man is dressed in buckskins, and another can be seen with a marching drum.

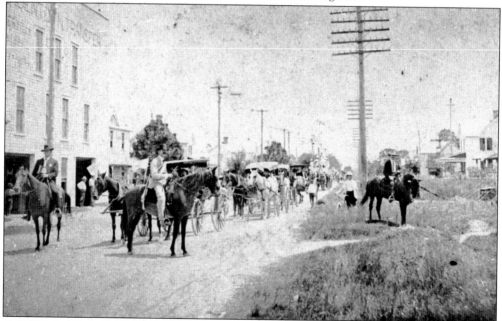

A 1905 Labor Day parade moves down Manatee Avenue in Bradenton past the Fogarty Brothers Transfer, Inc., building in horse-driven buggies. It was not unusual for cattle to roam into town to graze along the streets, but a few years after this photograph was taken, the ladies of the Improvement Association urged the town to ban cattle from Bradenton's streets.

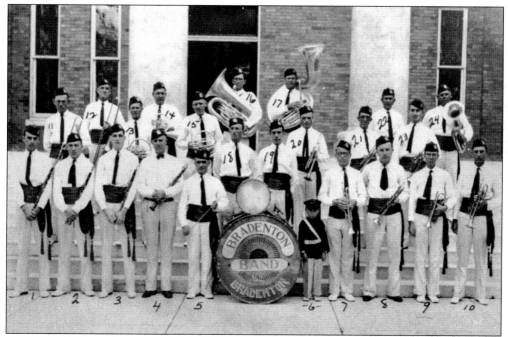

The Bradenton Concert Band in 1929 included, from left to right, (first row) W. White, Morris Schiller, Warren Battle, J. C. Haverhill, Arthur Silknitter, John Strickland, Jack Finny, Bill Kirke, G. Franklin Reeves, and Frank Sifert; (second row) Harold Hayworth, Bert Rose, Cole Weeks, Clarence Harvey, A. L. Hiday, Raymond Rood, Harry Fifeld, Ed Killshoe, Ira Haynes, P. S. McIntyre, Karl Roesch, and Bing Cowell; (third row) Buck Strickland and Arthur Tyler.

A group from the Village of Manatee have a picnic in 1916. Pictured from left to right are William Ellis Connell, Maude Thorpe, E. M. Thorpe, possibly Willa Stebbins, an unidentified couple holding a baby, and Marguerite and Milton Rushton. Marguerite was the sister of Mrs. Arndt Willa Stebbens.

Manatee County provided a bit of culture with the Warren Opera House located on 434 Main Street in Bradenton. L. R. Warren was proprietor, and H. G. Reed was manager of the opera house, located south of the Gaar House hotel. It was built of brick and advertised as the finest theatrical building on the west coast of Florida with a seating capacity of 800. Advertisers took advantage of the stage curtains.

An unidentified man fishes for mullet with a cast net from a dock on Terra Ceia Bay. Cast nets were commonly used and could be seen drying in the backyards of homes. The black mullet continues to be a favorite food for people on Florida's west coast, where they are smoked, fried, or barbecued. Cast nets made from synthetic material are more commonly used today.

The Manatee County Fair is held in Palmetto and is recognized as one of the best in Florida, particularly because of the exhibits presented by farmers, citrus growers, and cattlemen. This photograph shows the exhibit of the Future Farmers of America (FFA) with an award ribbon on the arch in the center. The display includes horticultural plants and produce. The FFA was particularly active in Palmetto as part of the high school curriculum.

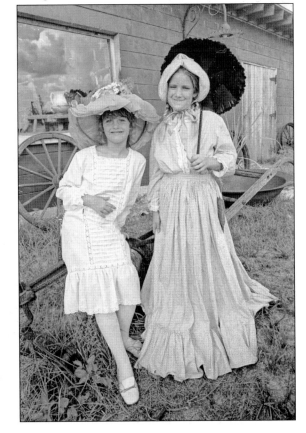

Two unidentified girls dress up in vintage clothes at the Country Fair, which is held in Oneco. Manatee County has many such celebrations throughout the area. Ellenton always held a Farmers' Day celebration during the early 1900s, and other rural communities held similar events, which often featured carnivals. Religious revivals and camp meetings were also popular events.

Unidentified young people enjoy the beach at Anna Maria Island during their summer break from school. This 1919 photograph was taken before the beaches were easily assessable. The only way to reach the island was by boat. The first bridge was begun two years later but was wiped out while halfway finished by a hurricane. The lumber was salvaged, and the bridge was finally completed in 1922 at a cost of $68,000.

Three unidentified boys sit in front of the Snead Island Cut-Off Bridge. This bridge connects Palmetto with Snead Island and also connects the Manatee River with Terra Ceia Bay. Terra Ceia has always been a popular area for fishermen and boaters. It was one of the earliest sites for farming in the white sandy soil.

Three people enjoy a motorboat ride on Gamble Creek in 1938. Gamble Creek was always one of the favorite destinations for quiet picnics, boat outings, or for fishing from the banks for bream or bass. The creek originates in Parrish and flows into the upper Manatee River. Portions of the creek remain today with its original pristine setting.

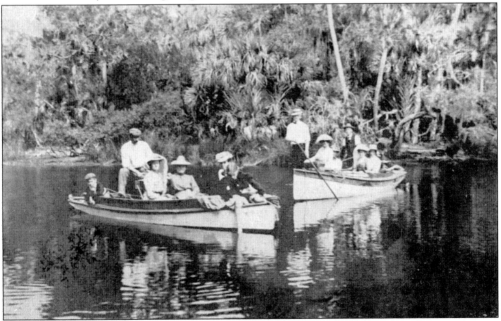

In this c. 1910 photograph, two boats filled with visitors enjoy the tropical atmosphere on the upper Manatee River. Guides and boats were readily available to take tourists on these adventures, where alligators and turtles were in abundance. It appears that these two boats are near the Rye area. The sighting of alligators was always a treat for visitors from the North.

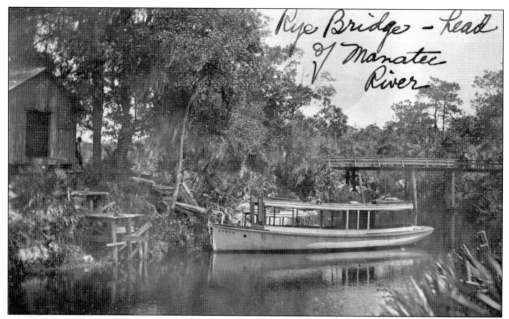

No place was more relaxing than Rye Bridge, where the surroundings were serene and pristine. The Manatee River was narrow, and the tropical setting included a white-sand beach. The launch *Sonia* is tied up near Erasmus Rye's store and rickety dock. The tourists will likely enjoy a picnic, but Rye Bridge was a favorite swimming spot for local residents.

Boy Scouts from Camp Flying Eagle on the upper Manatee River enjoy canoeing. The best part of Camp Flying Eagle was the white beach that sloped to the water near the Rye Bridge. The rest of the river usually had tree roots overhanging the banks that harbored snakes. This area was also a favorite spot for tent campers and hunters during the winter months.

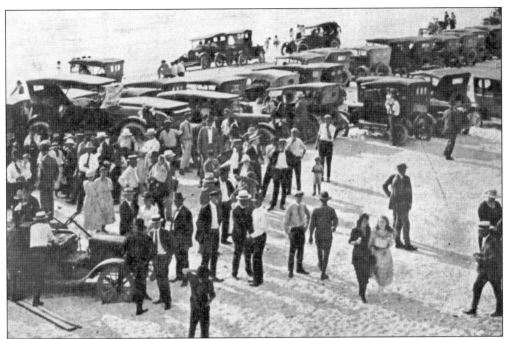

Cars were popular and plentiful in 1925 when this photograph was taken, tempting owners to show them off. The weather was ideal, and the white sugar sands of Bradenton Beach (also known as Cortez Beach) lured visitors in large numbers to gather. A few women and children mingle among the men who were wearing dress shirts, ties, and coats. Obviously they were not gathering at the beach to go swimming.

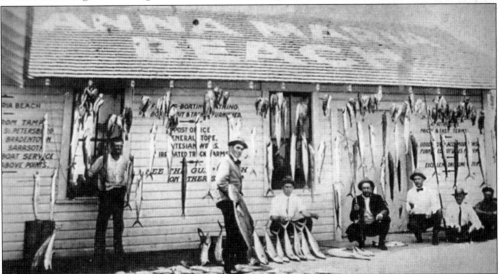

Unidentified fishermen display their catch on the pier at Anna Maria Island. The catch includes snapper, grouper, a large cobia, and king mackerel. The sign on the left advertises boat service to Tampa, St. Petersburg, Bradenton, and Sarasota. The middle sign offers fishing, boating, and bathing. Services include a post office, general store, artesian wells, and irrigated truck farms. The right sign offers easy terms and good accommodations. (Courtesy of the Anna Maria Island Historical Association.)

ACROSS AMERICA, PEOPLE ARE DISCOVERING SOMETHING WONDERFUL. THEIR HERITAGE.

Arcadia Publishing is the leading local history publisher in the United States. With more than 3,000 titles in print and hundreds of new titles released every year, Arcadia has extensive specialized experience chronicling the history of communities and celebrating America's hidden stories, bringing to life the people, places, and events from the past. To discover the history of other communities across the nation, please visit:

www.arcadiapublishing.com

Customized search tools allow you to find regional history books about the town where you grew up, the cities where your friends and family live, the town where your parents met, or even that retirement spot you've been dreaming about.